T-SHIRT AIRBRUSHING

THE STEP-BY-STEP GUIDE AND SHOWCASE

EXECUTIVE EDITOR
CLIFF STIEGLITZ

DESIGN/PRODUCTION
SARA DAY GRAPHIC DESIGN
BEVERLY, MASSACHUSETTS

First published in the United States of America by:
Rockport Publishers, Inc.
146 Granite Street
Rockport, Massachusetts 01966
Telephone: (508) 546-9590
Fax: (508) 546-7141
Telex: 5106019284 ROCKORT PUB

Distributed to the book trade and art trade in the U.S. by:
North Light, an imprint of
F & W Publications
1507 Dana Avenue
Cincinnati, Ohio 45207
Telephone: (513) 531-2222

Other distribution by:
Rockport Publishers, Inc.
Rockport, Massachusetts 01966

ISBN 1-56496-146-X

10 9 8 7 6 5 4 3 2

Printed in Singapore

T-SHIRT
AIRBRUSHING

THE STEP-BY-STEP GUIDE AND SHOWCASE

ROCKPORT PUBLISHERS • ROCKPORT, MASSACHUSETTS

DISTRIBUTED BY NORTH LIGHT BOOKS • CINCINNATI, OHIO

ACKNOWLEDGMENTS

We wish to thank all the dedicated professionals for their assistance and support in bringing T-Shirt Airbrushing: The Step-by-Step Guide and Showcase to completion. Special thanks also goes to the incredibly talented airbrush artists for their patience and tireless efforts during the preparation of this text.

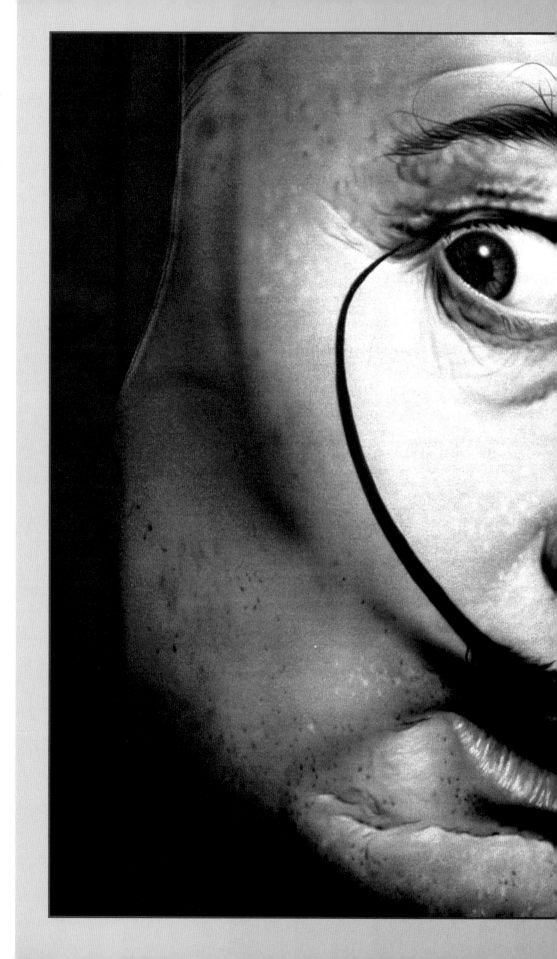

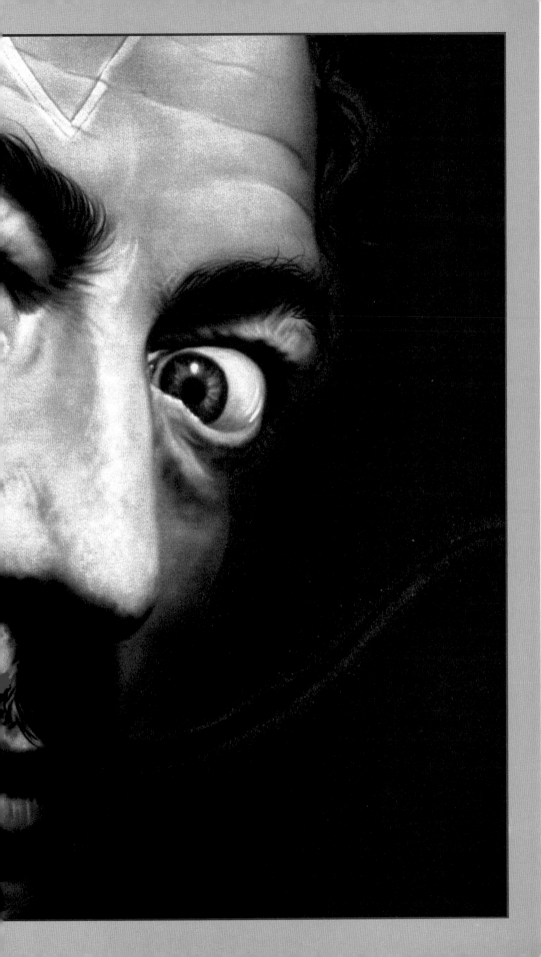

CONTENTS

INTRODUCTION

Ed "Big Daddy" Roth, king of the hot-rod and inventor of such weirdo monster designs as "Lover Boy", "Chevy Man", and, of course, "Rat Fink", was a 1950s airbrush pioneer instrumental in moving T-shirt design beyond felt-tipped-pen scrawls and giving it the streamlined airbrush look. Even so, the shirt artist of the past was low man on the totem pole of airbrush application. Not until 30 years later did shirt painting's popularity take hold. The T-shirt painter has officially arrived as a serious, respected, and legitimate artist.

About four years ago, I gave top technical illustrator Phil Adams a brief lesson in T-shirt airbrushing after he expressed disdain for the craft and the artist. Phil's sentiments seemed to reflect the general consensus. But after that ten-minute session, Phil never viewed the T-shirt airbrusher in lightweight terms again. He was impressed and humbled by the freehand mastery, and the detail achieved; he developed immediate respect for what he and many others saw as a doggerel art form.

I started out in the T-shirt and transfer (iron-on) business in the late 1970's. I worked local flea markets, street festivals in Manhattan, and New Jersey farm fairs. At the time, there was no magazine covering the subject, nor were there videos, workshops, books, or other shirt artists within driving distance from which to glean information. I was on my own. My first attempts were clumsy and dreadful. I'm convinced that customers bought out of sheer sympathy.

Today it is easier to develop these skills. Nowadays, what took me years to learn on my own—the flare, the rat tail, or the dagger—can be quickly taught to students in an airbrush workshop.

I'm sure you'll agree that the quality of the work by the featured artists is superb and worthy of respect. The quality in the shirt field has gotton so good that, in my opinion, the difference between the shirt artist and the illustrator is the surface they work on and the price paid for their work.

In fact, artists of other disciplines will discover that many of the techniques and "tricks" invented and taught by shirt artists easily translate to their airbrush application.

T-shirt art now provides teenagers with a fun and exciting way to make thousands of dollars at a summer job, gives adults a relatively inexpensive way to start their own businesses, and is on the way to demistifying a craft that may initially seem too difficult or requiring too much artistic ability. After reading this book, you'll realize that artistic ability is most definitely not mandatory.

I wish to dedicate this book to the gifted shirt artists who finally let their guard down, and revealed the secrets and nuances of their trade. Their commitment to sharing has paved the way for talented new artists who might otherwise have followed different paths. Shirt airbrushing is far more accepted today than it was even five years ago thanks to these individuals, Airbrush Action, and Rockport Publishers.

— Cliff Stieglitz, Publisher, Airbrush Action

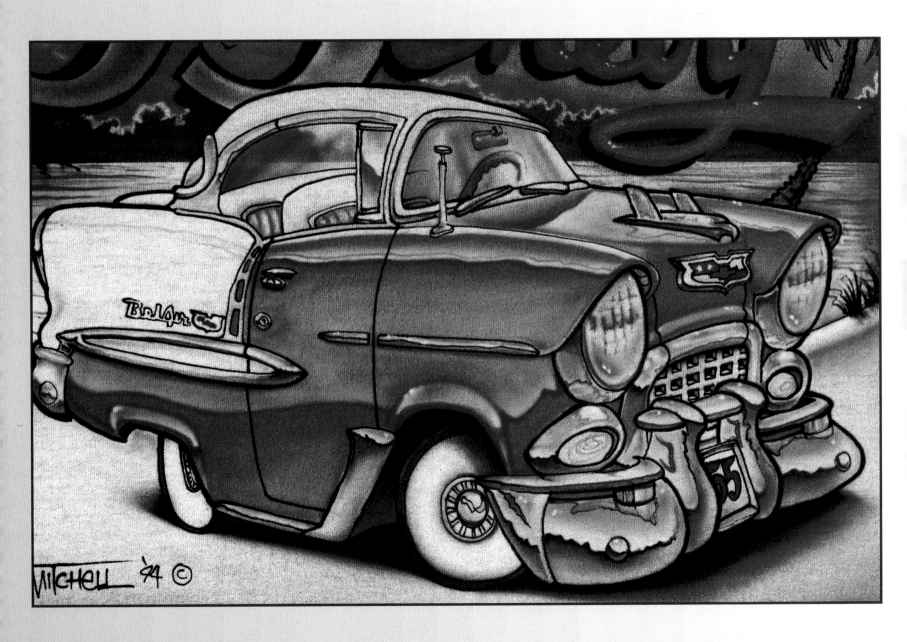

MITCHELL '94 ©

TECHINQ

TECHNIQUES

The focus of this book is to help raise the standard and integrity of T-shirt airbrushing by demonstrating in great detail the techniques and methodology of the nation's top T-shirt airbrush artists. It bears repeating—from the pages of Airbrush Action 2, the book, and Airbrush Action magazine—that artists cannot improve with mediocrity as their model. Thus, we feel it is our duty to incorporate the best. Throughout these pages, you will encounter examples of some of the most professional-quality art being produced on fabric today. To get the most out of this book employ the techniques shown, adapting them as you go along to suit your own personal style.

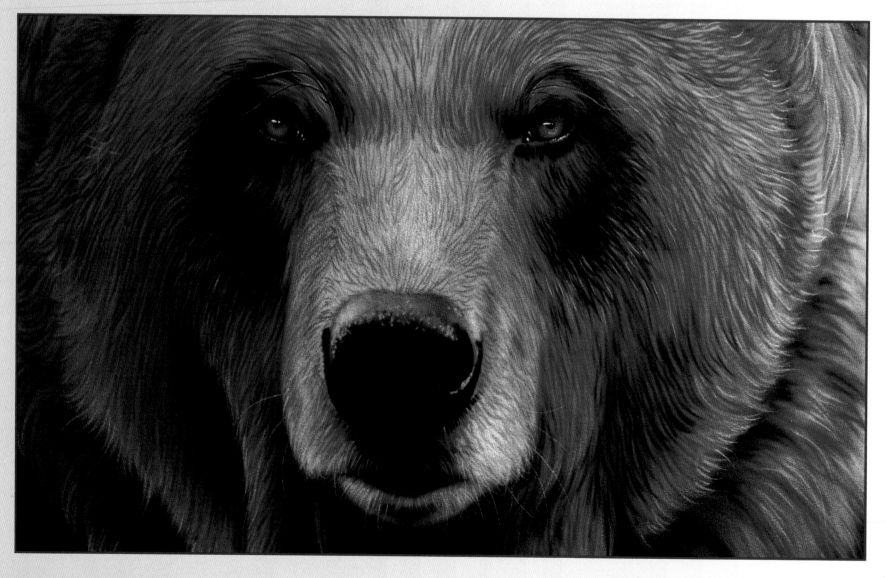

T-SHIRT BASICS

Choose a shirt that is smooth and has a tight weave— the Jerzees brand 100 percent cotton or 50/50 polyester/cotton blend shirts are preferred. White is the best color choice, since the color of the shirt does not interfere with the airbrush colors applied. Choose fairly heavy cotton shirts, to ensure that customers are receiving the artwork on high-quality garments.

To start, stretch a white T-shirt over an appropriate-size board, making it wrinkle free. Be careful not to over-stretch the shirt, or the finished artwork will be distorted when it is removed from the board. Because T-shirt material is loose and stretchy, the preliminary sketch must be made in a scrubbing manner. If this becomes too much of a problem, a light coat of spray adhesive will stick the shirt to the board and provide a firmer surface to sketch on. If you do use adhesive, do not press the shirt while it is on the board; the heat will make it adhere there permanently.

Use masking tape to block off the collar, sleeves, and bottom hem of the shirt. The sleeves should be taped flat to the back of the shirt, and the tape should be layered from the outer edge inward. If the tape is not layered, paint may become trapped in a lifted edge—leaving dotted overspray on a clean area.

If you are using a projector to sketch the image onto the shirt, place it perpendicular to the plane of the shirt's surface and aim directly at its center. Any strange angles will distort the image. The reference picture should be sharp, clear, and of a size sufficient to show detail. Only reference lines should be sketched, not the different gradations of shading.

Photographs are the preferred reference, and save sketching time. Once the base sketch is made on the T-shirt, spray a light coat of top binder, a clear coat, or a color that matches the shirt over the sketch. The shirt will probably be worn, so try not to place the sketch too low. Press the shirt again, using a Teflon sheet to prevent sticking. This process glues down the nap of the shirt and eliminates the "overspray fuzzies." If this is not done the artwork may have a spotted or grainy look. Use a hair dryer to dry the shirt in between steps.

STIPPLING AND GRANITE EFFECTS

The stippling method used to create the stone or granite effect involves deflecting the paint flow off just about any object that can be held conveniently in hand, such as a clothespin or tongue depressor. This method works with any airbrush, without changing the normal air pressure. Position the airbrush at a 45 degree angle toward the front end of the object chosen to deflect the paint. The object will direct your aim, as well as control the stippling.

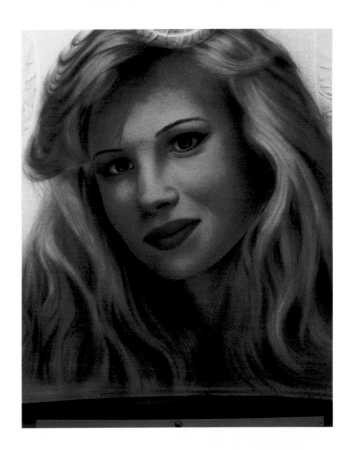

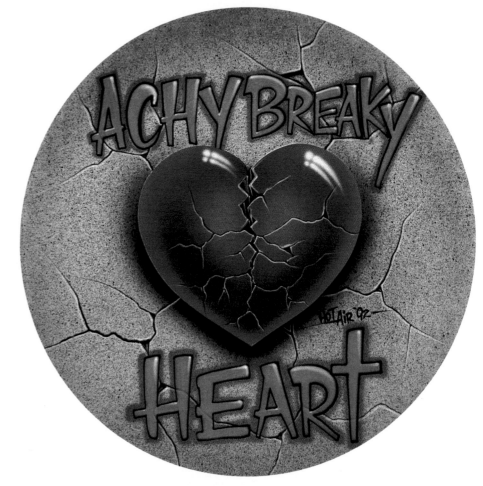

To create concentrated areas of stippling, hold the airbrush three to six inches from the surface of the T-shirt. Press the trigger all the way down for maximum air flow and pull back slightly to release a small amount of paint. To create a more loosely stippled effect, simply move the airbrush back six to twelve inches from the surface. Larger dot patterns can be produced by backing away as far as 20 inches, fully throttling the trigger, and experimenting with various amounts of air pressure.

To create the effect of granite, stipple the desired area with shades of black, violet, and deep blue. Add erratic cracks with black paint, highlighting only one edge with opaque white to suggest a light source.

MARBLEIZING

Marbleizing with the airbrush, much like stippling, involves the use of an additional tool, a plastic bag. To marbleize a T-shirt background or picture, place a plastic sandwich bag over the hand opposite the airbrush, and separate it between each finger. Without destroying its shape, cover the bag with paint and randomly dab the desired area. This will create the abstract shapes and forms often found in real marble. Choose colors that complement the base color and lightly haze over the entire area. Slightly darken the edges of the marbled section, fading in towards the center. Finish the marble effect by adding fine black cracks, with opaque white highlights on one edge. Random veins through the marble may also be added with opaque white.

NAME DESIGN

Whether it's the centerpiece, the crowning achievement, or just the icing on the illustration cake, lettering plays an increasingly important role in all art forms, especially T-shirts. Lettering should be considered as carefully as the art airbrushed on the shirt, since it will inspire an emotional reaction in the viewer. Although custom T-shirt designs are eye-catching and offer the chance to showcase ability, traditional name designs are the real money makers. Quick name designs are fast, flashy, and highly profitable, with an average price ranging from twelve to twenty five dollars (T-shirt included.)

When designing a lettering style, keep the line quality, the angle of the lettering, and the overall composition of each design consistent. Notice the continuity and similar design elements in the alphabet provided; instead of 26 different looks, each letter is part of the whole. Likewise, the color scheme should be coordinated, and close attention should be paid to the legibility of the lettering. When it comes to customer satisfaction with a T-shirt, the lettering can *make it or break it.*

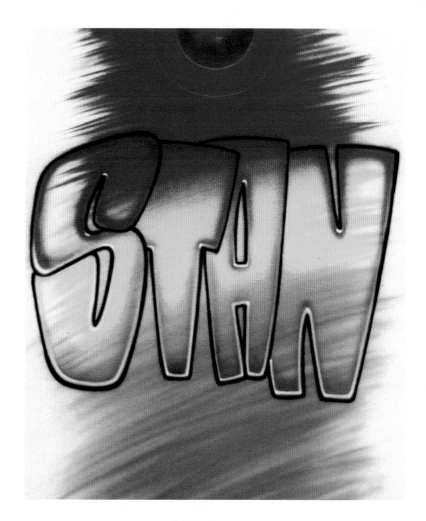

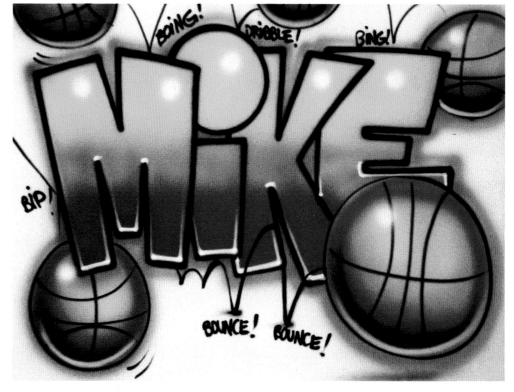

KENT LIND

Kent Lind is an airbrush artist who lives and works in the Minneapolis area. He began his self-taught airbrushing career in a park just outside of Chicago. From there, Lind moved on to become manager of an airbrush store and is now part owner of the Minneapolis T-shirt shop, Air 2B Difrent. Although Lind's specialty is cartooning, his art ranges from lettering to portraits. His style, awareness, and attention to detail contribute to his overall design sensitivity.

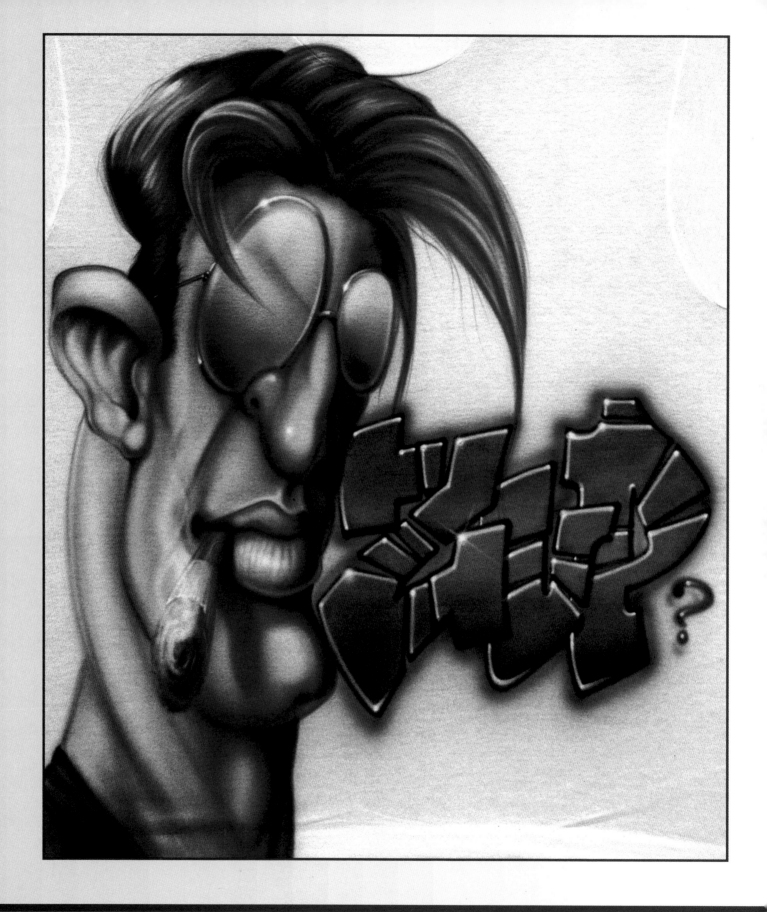

DYNAMIC LETTERING

The pitfalls to creating good lettering are often considered less important than the difficulties encountered in "custom" work. This has always amazed me. Ask any T-shirt artist what produces the most income, and "stock designs with a lot of lettering" is the nearly universal answer.

Consistency is one of the most frequently encountered lettering problems. By consistency I mean: the height of each letter; the angle of execution; the line quality; and most important, giving similar letters the same structure.

Being consistent, however, shouldn't mean being boring. Lack of variation can be a problem, too. Pay attention to legibility, but create each letter with finesse. Keep the lines expressive, free-flowing, and just consistent enough to give your word overall appeal.

TOOLS:

PAINT:
Createx Transparent Airbrush Colors
AIRBRUSH:
Thayer and Chandler's Vega 2000
AIRBRUSH COMPRESSOR:
Silentaire 1-Horsepower Compressor
VENTILATION:
Respro Ventilation Mask
HEAT PRESS:
Stahls Heat Press

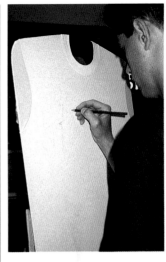
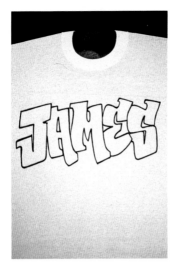
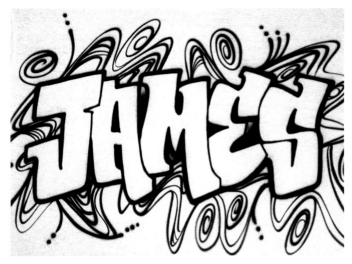

STEP 1. Pencil in the name. As you become more proficient, you will be able to skip this step and simply freehand it.

STEP 2. Outline the letters in opaque black. In this step, consistency, line quality, and composition will make or break your design.

STEP 3. Add in the swirls. Remember that a combination of care-free expressive lines mixed with a precise composition is a must to create a feeling of movement around the design.

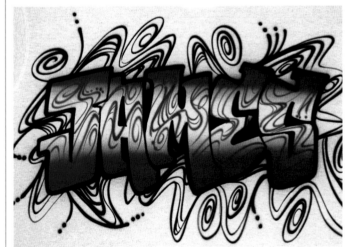
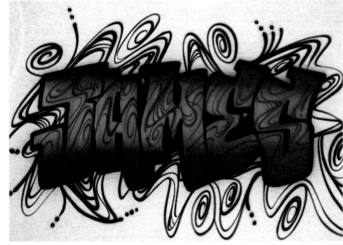

STEP 4. Color the lettering by fading pthalo blue from the top and bottom of the letters. Add swirls (as in Step 3) in the center of the letters, using the same color.

STEP 5. Fade in the centers of the lettering in aqua, smoothly blending the aqua into the blue.

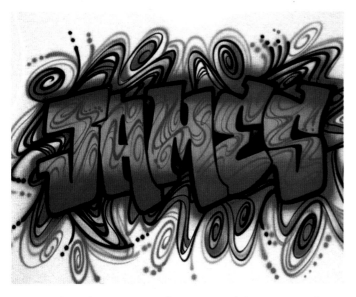

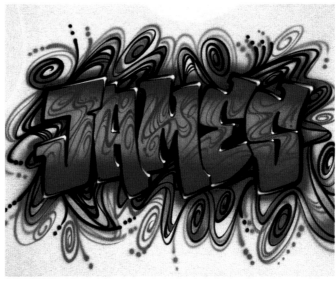

STEP 6. The color mixture in the outer swirls is a mixture of equal parts violet and fluorescent raspberry. These swirls should shadow the black swirls, but may be used wherever more movement is needed.

STEP 7. Using opaque white, paint in the highlights. Here, the highlights are oriented towards an upper right light source. Highlights should only appear on the areas that would naturally catch and reflect light. Since the bottoms of the letters were dark, the artist added a secondary lightsource, and secondary highlights in aqua.

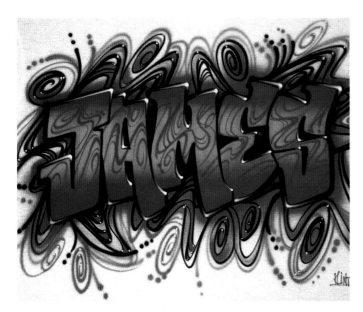

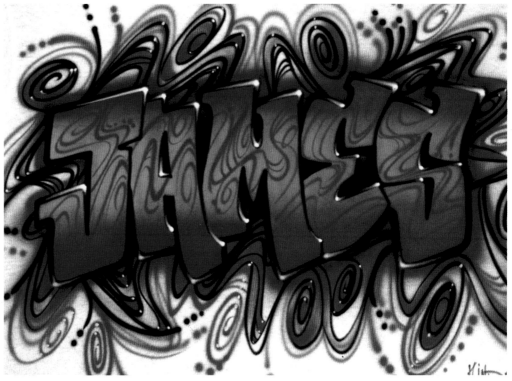

STEP 8. Finish the design off by adding highlights wherever a boost is needed.

STEP 9. Lettering, color, movement, and highlights work together to bring the design to life.

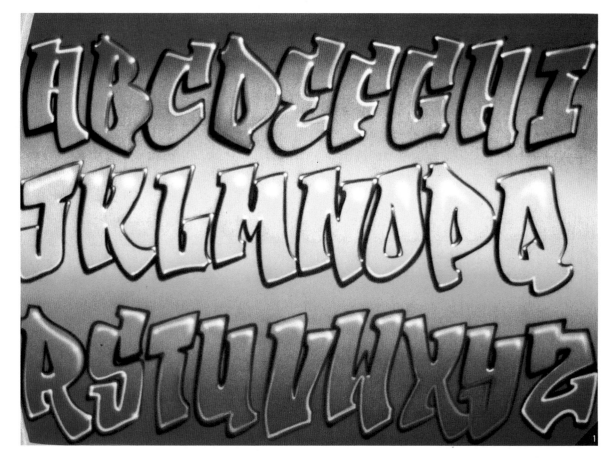

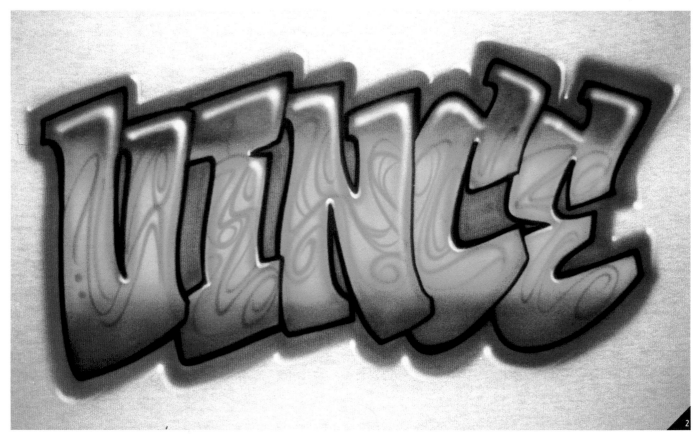

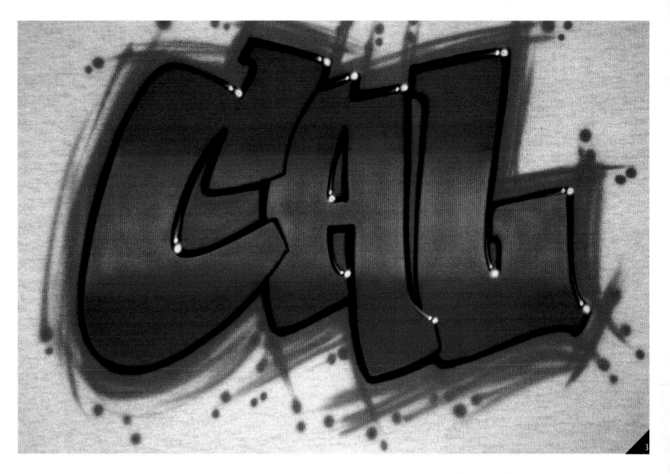

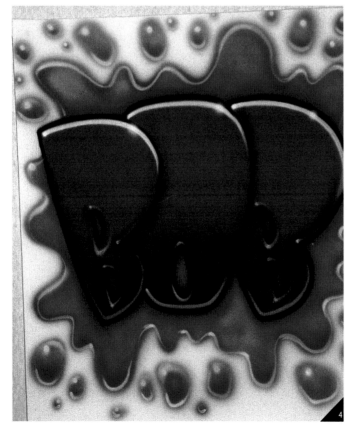

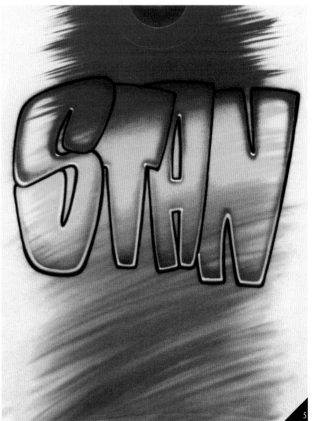

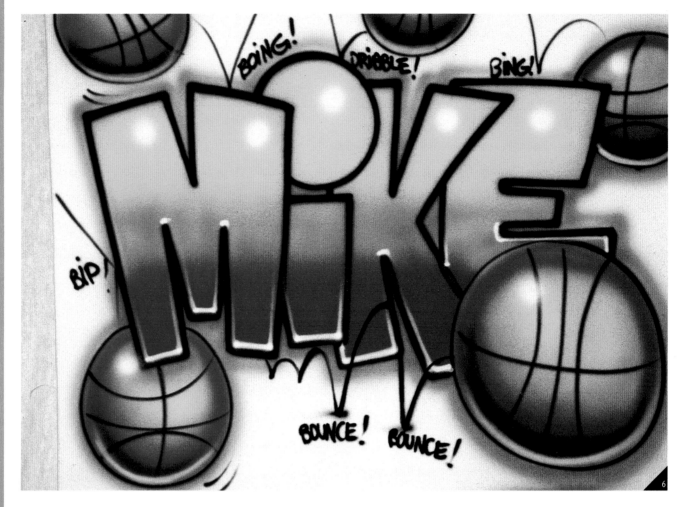

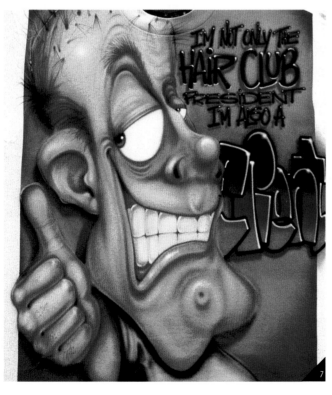

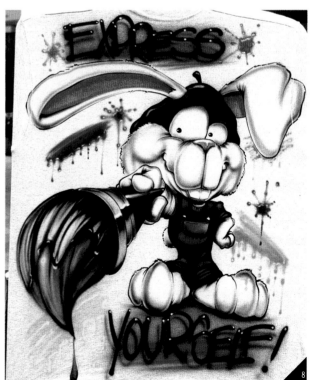

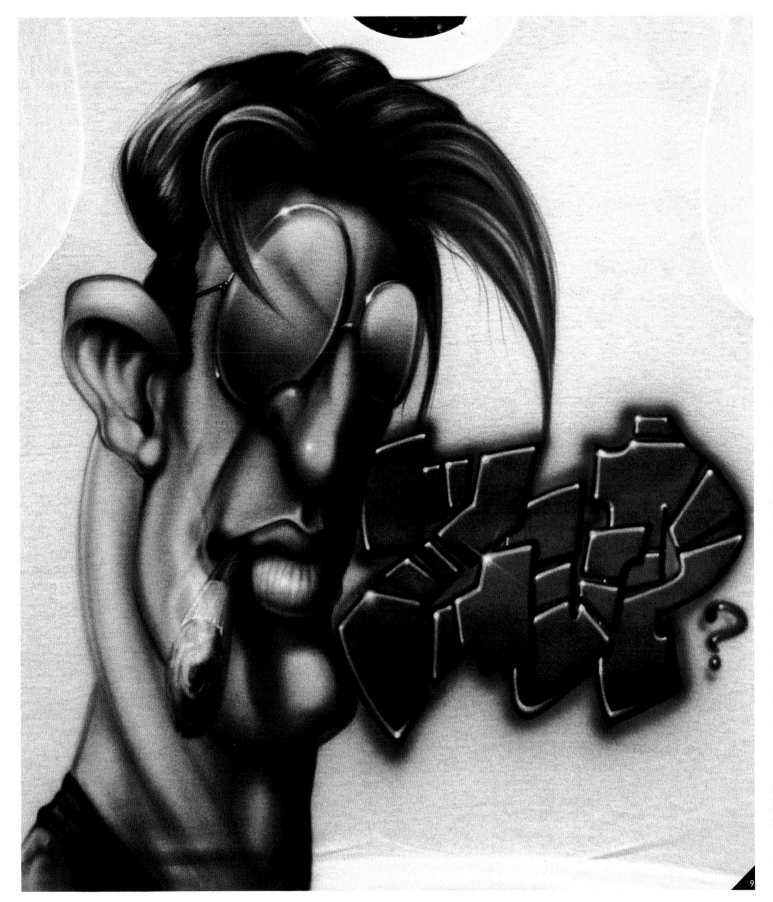

KENT LIND

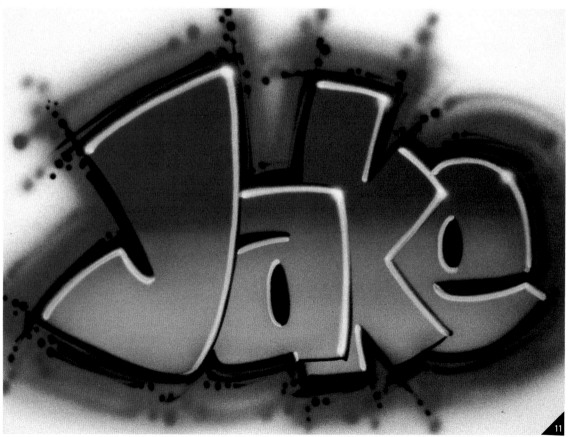

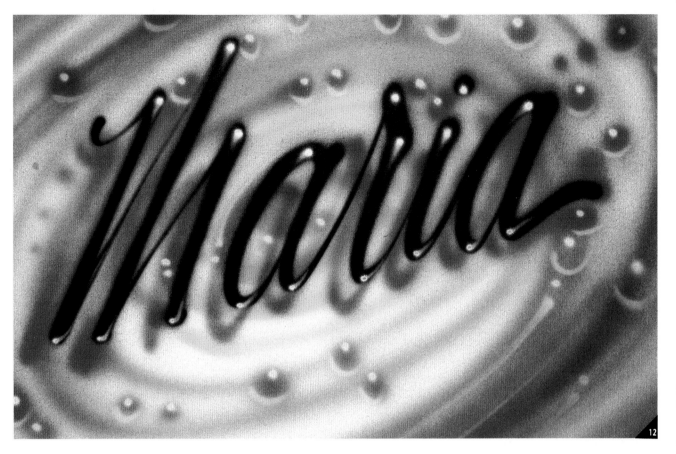

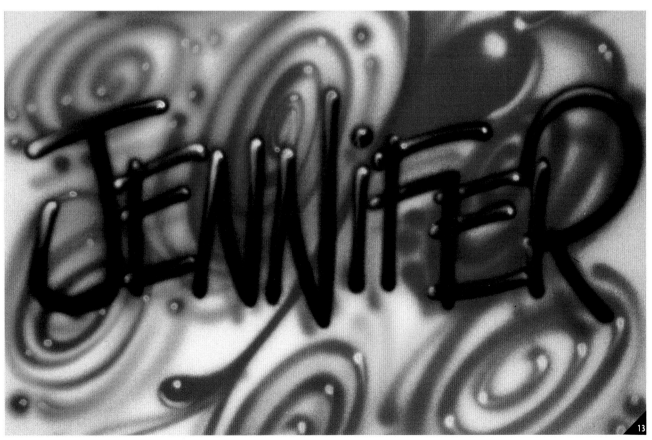

TIM MITCHELL

Tim Mitchell has been airbrushing for twenty-one years. He resides in Panama City Beach, Florida, and primarily concentrates his artistic efforts on cartoons—but is known for his ability to paint anything brought in to him. A frequent contributor to Airbrush Action magazine, he is also a spokesman for Badger and Excaliber paints. Currently, Mitchell is focusing his talents on the lithograph market.

Mitchell's cartoons stretch, shorten, exaggerate, and enhance the prominent features of their subjects, without losing focus or detail. The following step-by-step procedure shows how he airbrushes a 1955 Chevy, and manages to keep it from looking like a '57, or another model year. Mitchell combines imagination and caricature technique to make the car's noticeable features even larger than life.

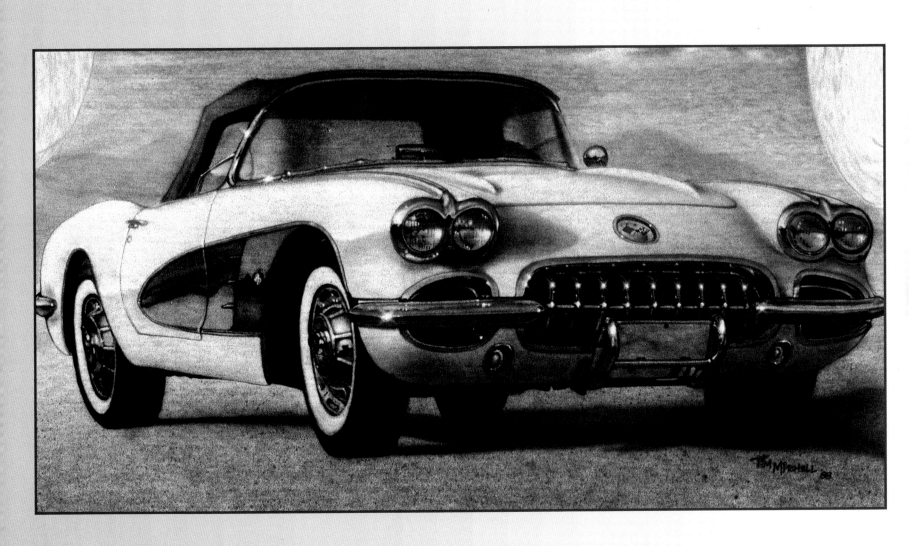

CAR-TOON

Drawing a caricature isn't as easy as it looks. At first I had to work at it, but after a short time I became proficient at caricaturing almost any car. Even though they take just as long, and in some cases may be even harder than doing a "realistic" car portrait, I usually charge less for caricatures because I have fun with them.

Caricatures allow me to make noticeable features larger than life, and to use my imagination to the fullest. There are really no set rules, provided the object remains recognizeable. Among the beach scenes, name designs, tag designs, and typical display art, I have always tried to have as wide a variety of custom work as I could squeeze in. A great cartoon makes its impact immediately, but can stay in the mind for years afterwards. The best T-shirt cartoons are as much fun for the artist to draw as they are for the viewer to enjoy.

TOOLS:

PAINT:
Badger Air-Opaque, i.Createx, Excalib-air, and Aqua-Flow
AIRBRUSH:
Badger's Crescendo Airbrush
AIRBRUSH COMPRESSOR:
Badger 180-11
VENTILATION:
Natural ventilation
HEAT PRESS:
Hix Heat Press

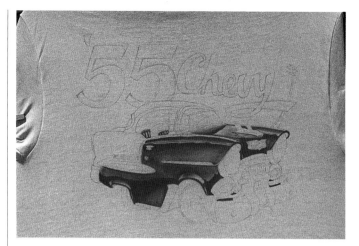

STEP 1. Using a good reference, sketch or trace the caricature onto the T-shirt with an ebony pencil. Begin coloring the picture, using the white of the shirt for the highlights and reflections.

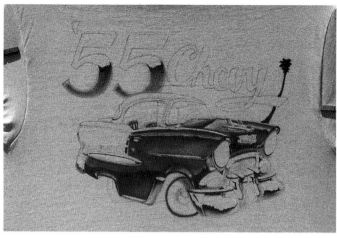

STEP 2. Paint in the chrome reflections on the car and lettering ('55), and shade the trunk of the palm tree using opaque brown.

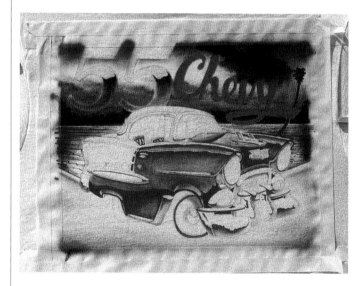

STEP 3. Mask off a rectangle of the shirt with standard masking tape and paint in a sunset background. Color the word "Chevy" in hot pink.

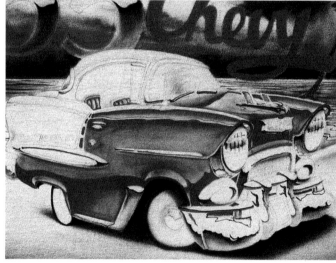

STEP 4. Add purple shading to the chrome, the lettering ('55), the headlights, and the ground shadow.

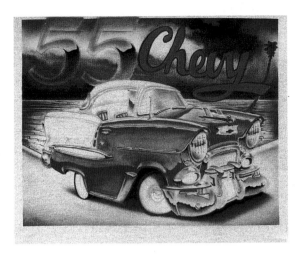

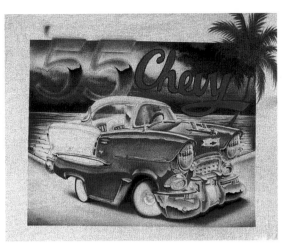

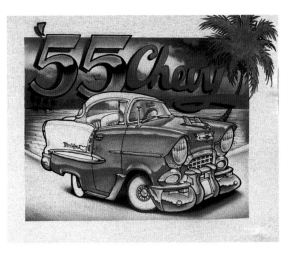

STEP 5. Add opaque sky blue to the chrome areas, the lettering ('55), and the windshield.

STEP 6. Complete the palm tree leaves using green. Add yellow highlights to separate the leaves and the coconuts.

STEP 7. Outline the images and lettering with opaque black, and lightly fade blue on the word "Chevy."

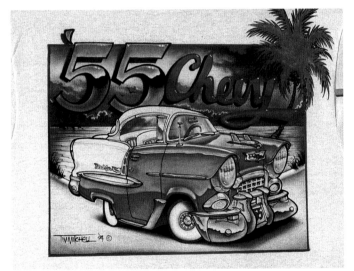

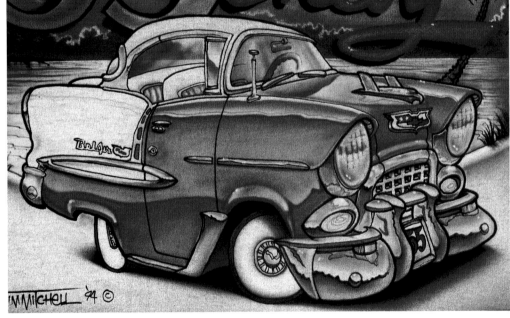

STEP 8. Border the rectangle with red and accent the darker areas of the car.

STEP 9. Add white highlights to the body of the car and to the chrome to bring the car to life.

TIM MITCHELL

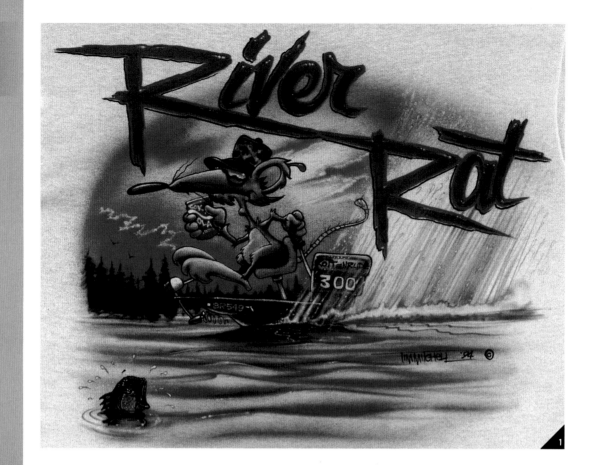

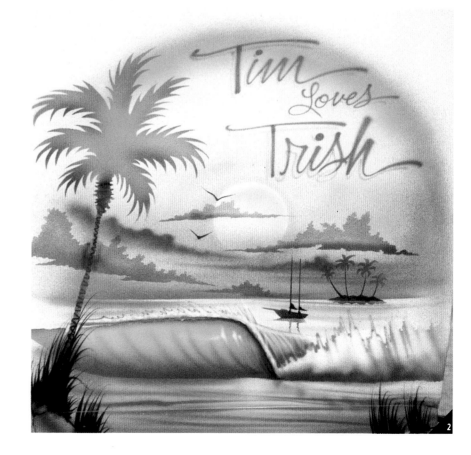

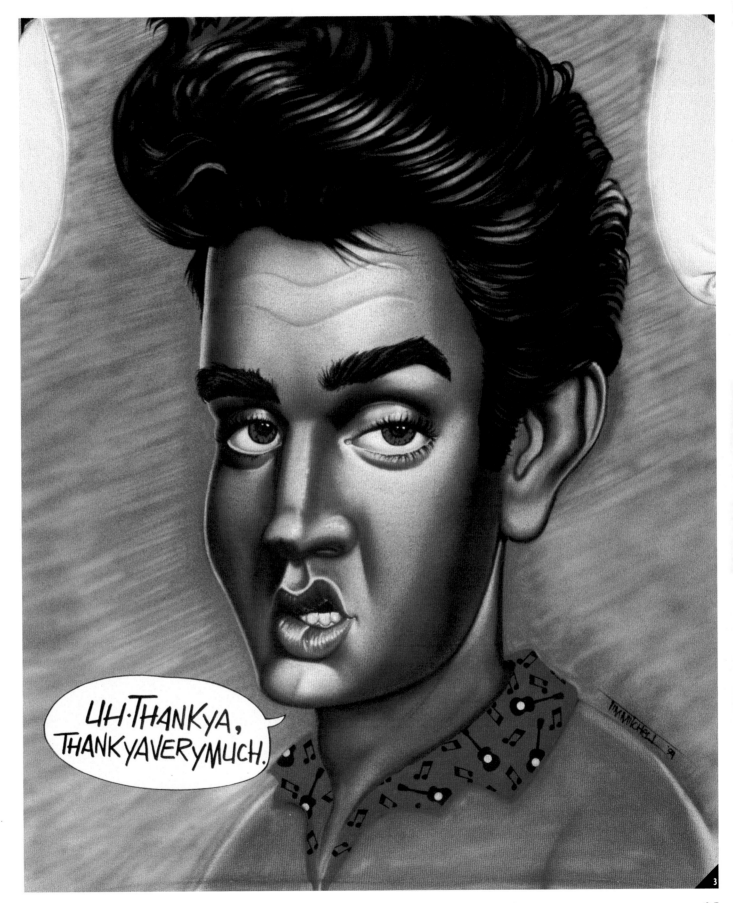

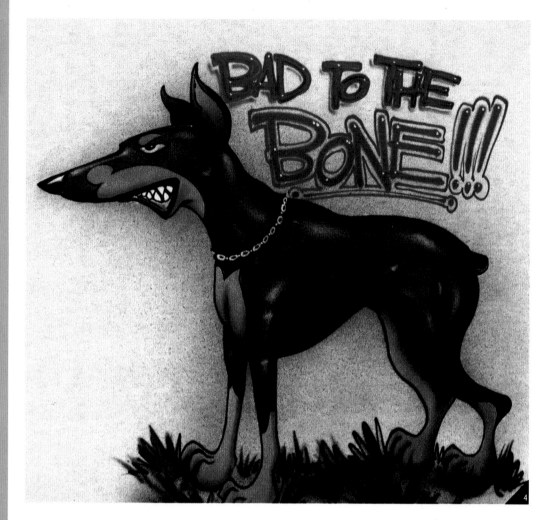

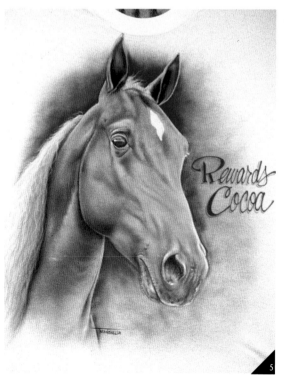

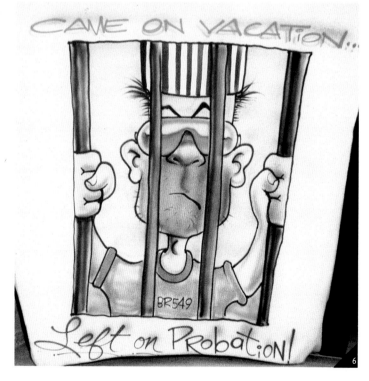

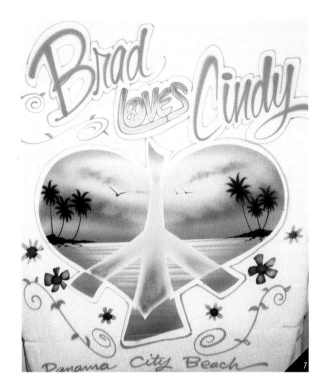

7

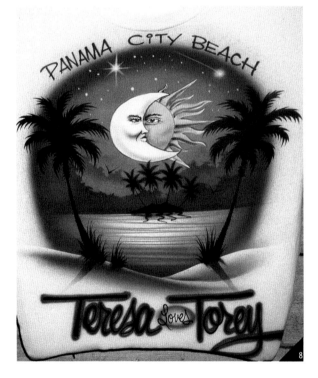

8

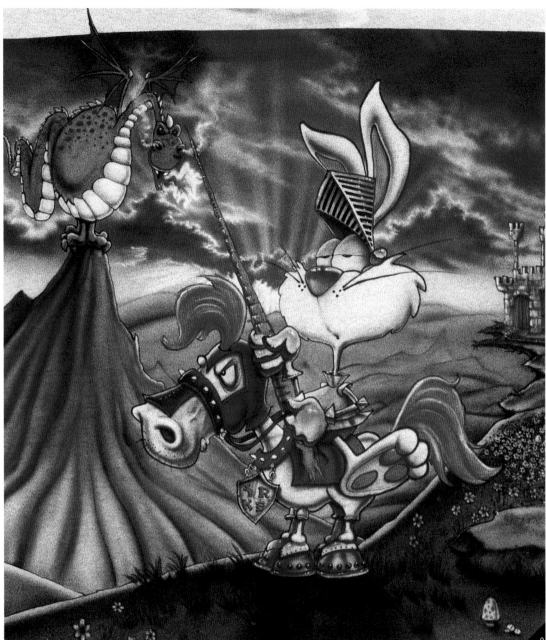

9

TIM MITCHELL

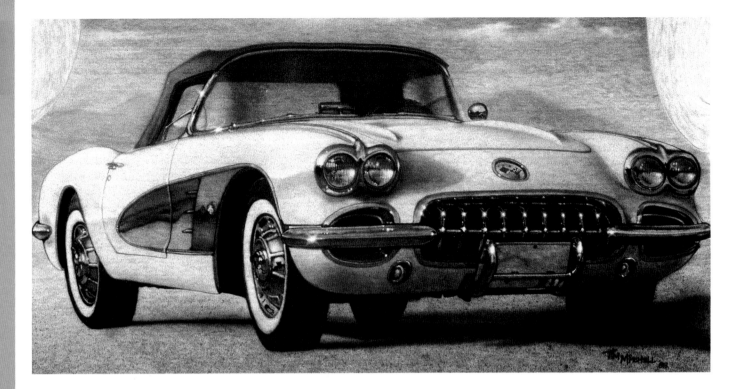

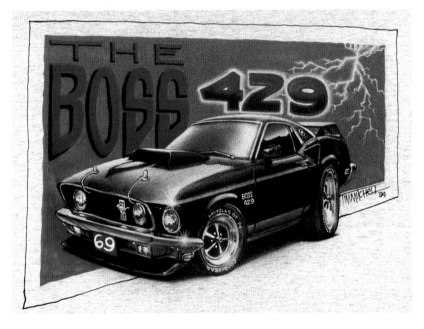

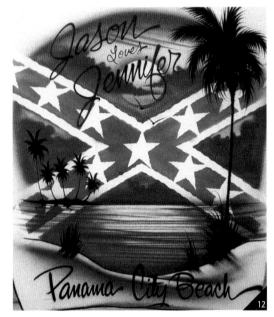

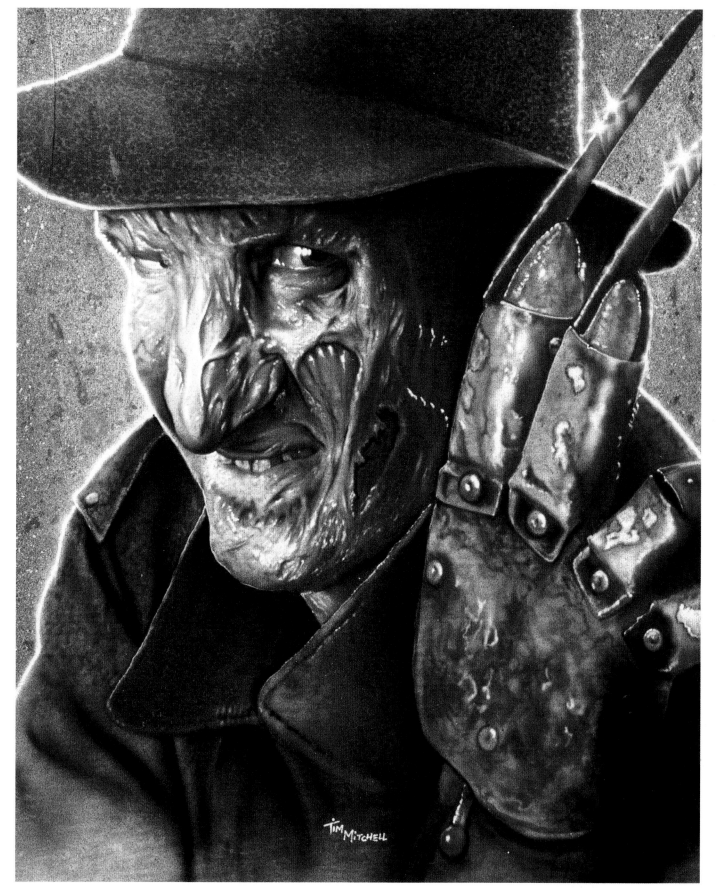

TIM MITCHELL

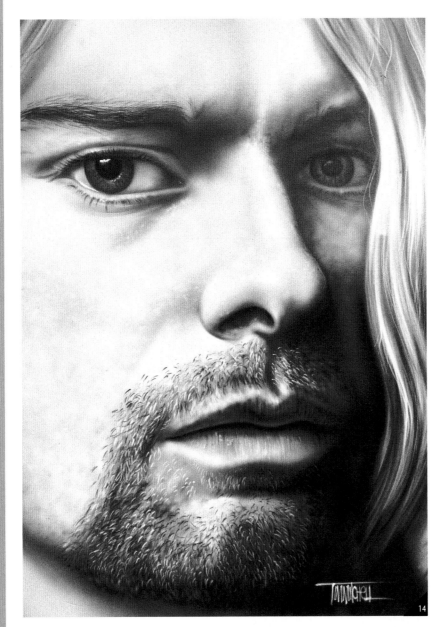

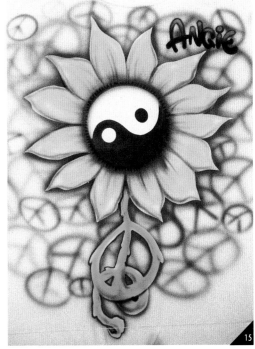

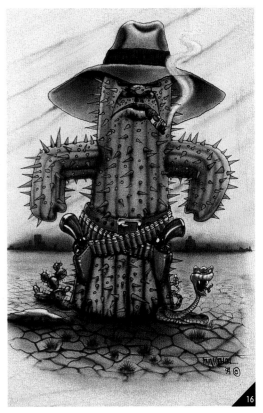

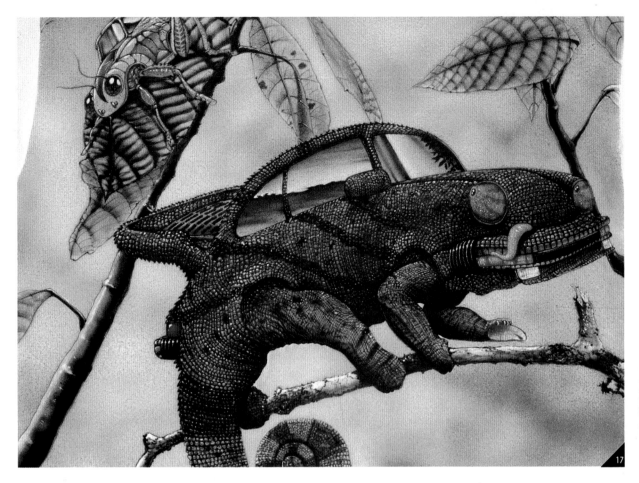

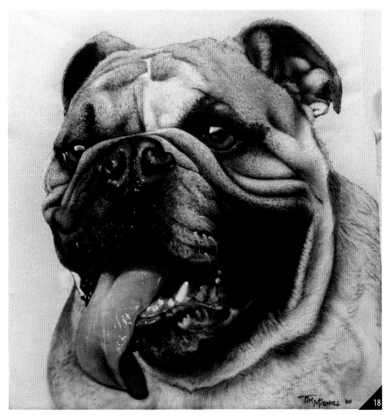

ASHWO

DON

ASHWO

DON ASHWOOD

Don Ashwood is a Fort Walton Beach airbrusher who specializes in cartooning. He has been airbrushing since 1977 and was responsible for bringing Terry Hill into the field. Known for having the cleanest, sharpest artwork around, Ashwood uses positive (cut-outs) and negative (the hole left by the cut-out) stencils to create an image. Ashwood's philosophy is simple: Cartoons sell if they are done well. Criteria? Well, they should be clean, cute, and painted in under twenty minutes.

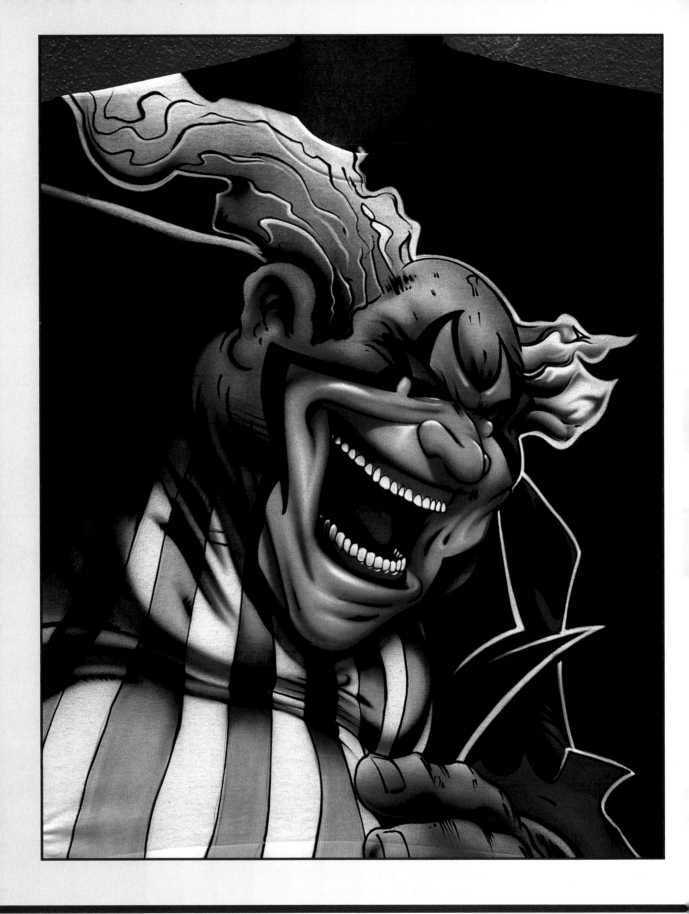

STENCILING FOR A CLEAN LINE

Cartoons have always been my favorite subjects to paint. They convey strong emotions and can capture any experience or situation. I often use stencils to create air brush cartoons. Stenciling is really not hard to figure out. An image is drawn on durable material, then cut out using an X-Acto knife. The cut-out is the positive stencil, the cut-into piece is the negative stencil.

More than half of the stock design I display consists of these little critters, and accounts for 60 to 70 percent of the business each summer. Stock cartoons must be fast (under 15 minutes to finish) and easy to duplicate consistently: the curves must be natural and well-planned. This how-to illustrates the techniques used to create Iko and his animal urge to surf.

TOOLS:

PAINT:
Createx Transparent Airbrush Colors
AIRBRUSH:
Thayer and Chandler's Vega 2000, Iwata HP-BC 2 Airbrush (for detail)
AIRBRUSH COMPRESSOR:
Professional Model Compressor by Silentaire
VENTILATION:
Ventilation System Built into Easel
HEAT PRESS:
Hix HT400 Heat Press

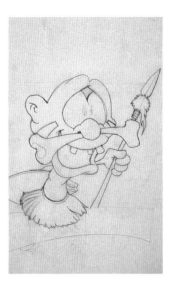

STEP 1. Make a graphite sketch on Frisk C-Trace with a 6B graphite pencil. Put the sketch on a posterboard and rub it down to transfer it, making a stencil. Enough graphite should be on the tracing paper for several transfers.

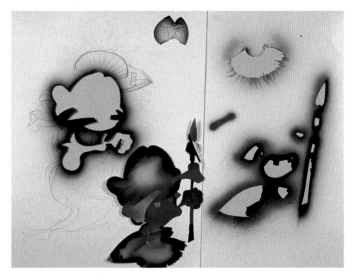

STEP 2. Create an array of images on the posterboard, then cut them out using an X-Acto knife. Cut two positive stencils for the eyes and face, and three negative stencils for the head, war paint, spear, mouth, surfboard, and grass skirt. Use 3M Super 77 Spray Adhesive to keep the stencils in place.

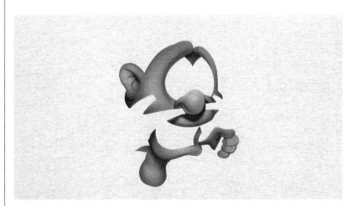

STEP 3. Center the negative stencil of the head on the T-shirt and align the positive eye stencil in the proper area. Airbrush flesh tones, then use Createx gray to form the shadows on the head and hands. Finish up the flesh portion with light brown.

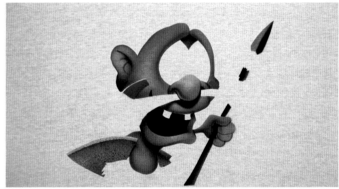

STEP 4. Align the negative stencil of war paint, spear, mouth, and surfboard with the head stencil. Use fluorescent red and burgundy for the war paint, black and dark brown for the spear, and black for the mouth.

STEP 5. Position the negative stencil of the grass skirt, using fluorescent yellow as a base, and adding texture with light brown linework. Create a drop shadow by placing the third negative stencil about 1/4 inch to the bottom right of the image. Slightly fade gray into this area.

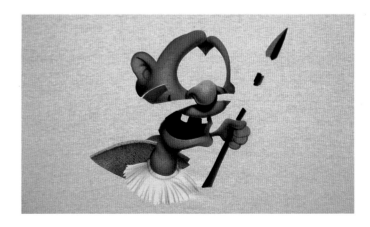

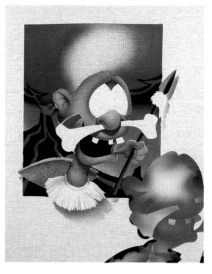

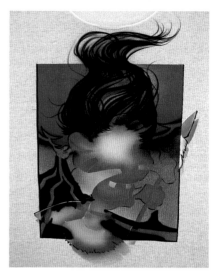

STEP 6. To create a background, position the remaining positive stencil of the head, and place a negative rectangle stencil over it.

STEP 7. Color the background freehand with fluorescent red and pink, pthalo blue, burgundy, and black.

STEP 8. Paint the hair, using gray and light brown, and black. The black produces the shadows and the continuous flow of the strands.

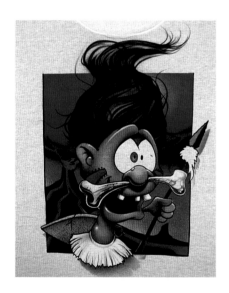

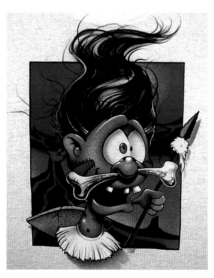

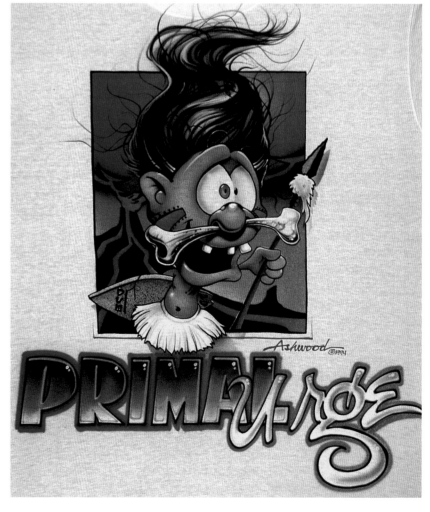

STEP 9. Remove all stencils. Notice the slight registration problem that occurred around the ear and lower lip. This is not a problem. Add a black outline to produce a freehand feel. This also cleans up the design and covers any alignment problems caused by the stencils.

STEP 10. Shade the character's nosebone while black is still in hand. Highlight the artwork with Createx opaque white. Backlight from the volcano should be added to the hair using fluorescent red over the white highlights.

STEP 11. Use fluorescent yellow for the spear and tassel, to balance the yellow in the grass skirt. Then add light brown strokes to shade and texture the tassel.

DON ASHWOOD

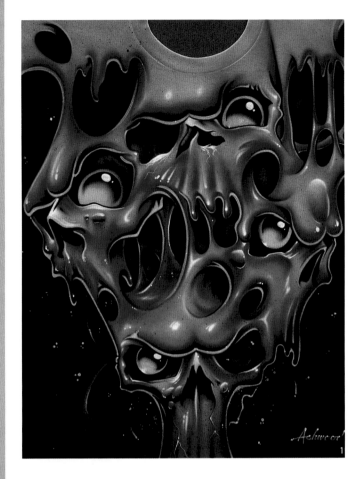

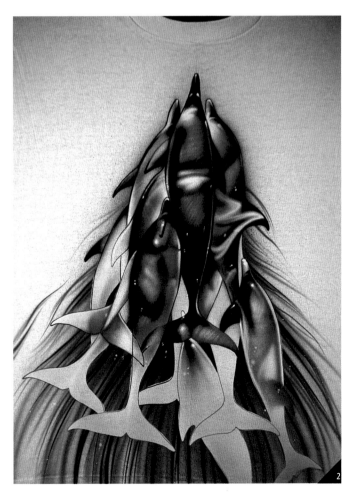

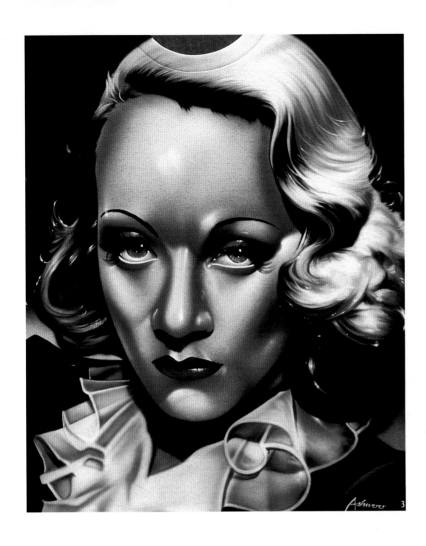

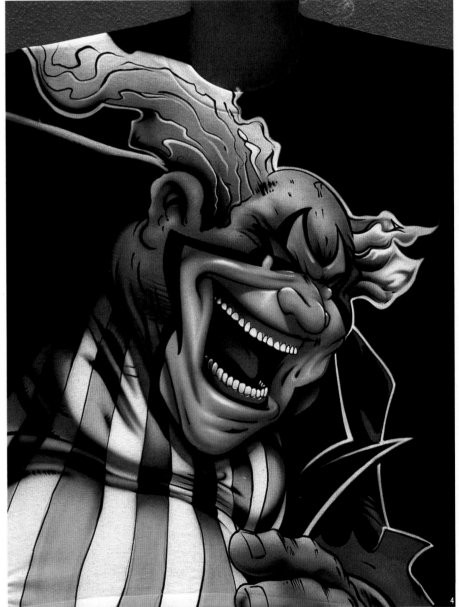

DON ASHWOOD

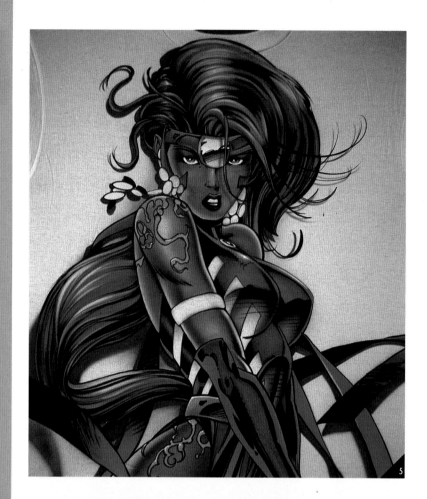

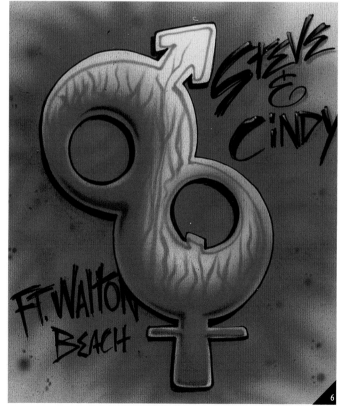

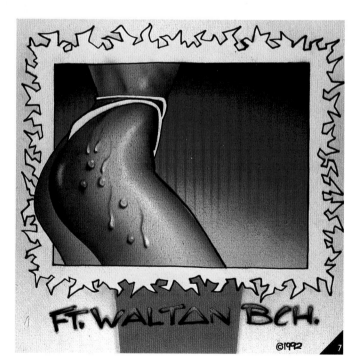

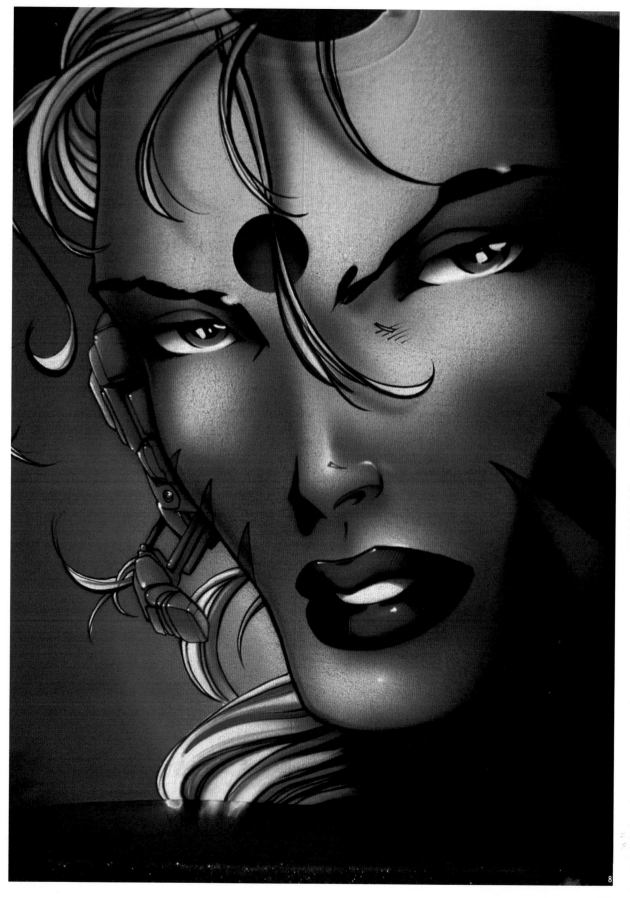

DON ASHWOOD

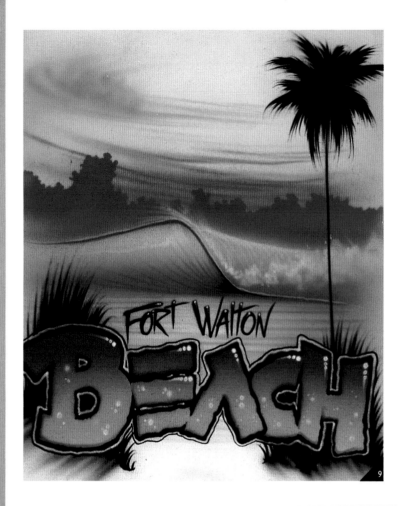

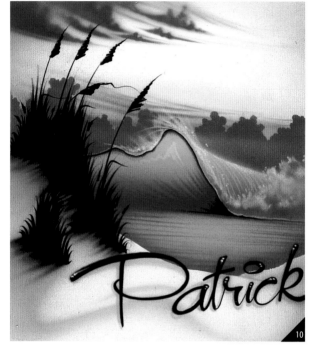

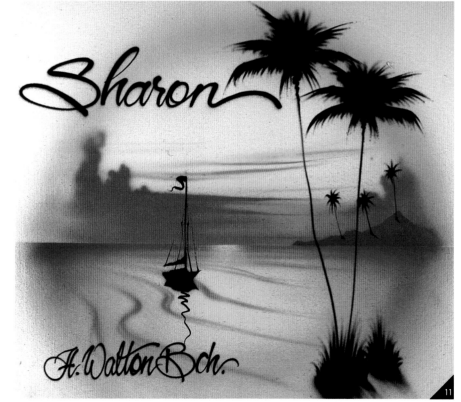

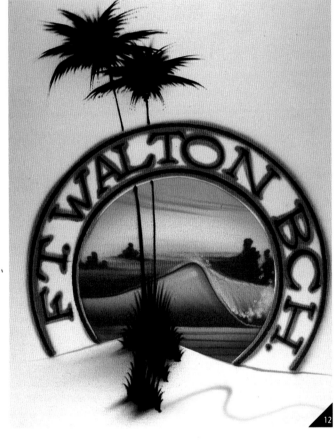

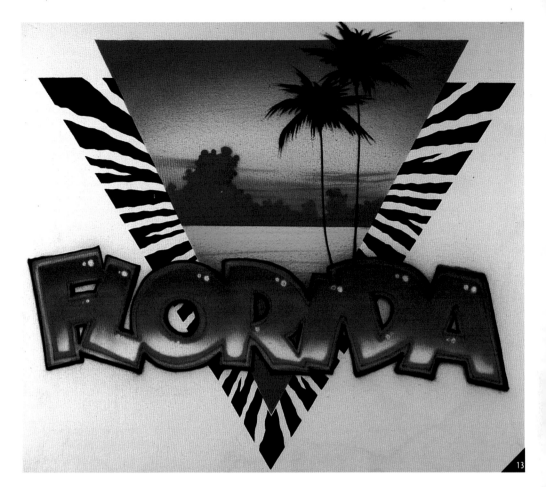

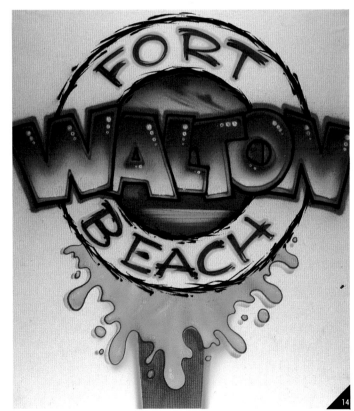

DON
ASHWOOD

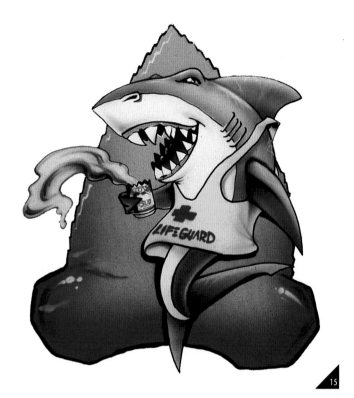

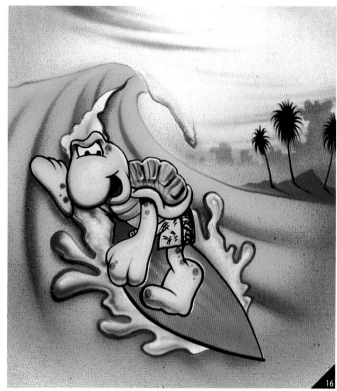

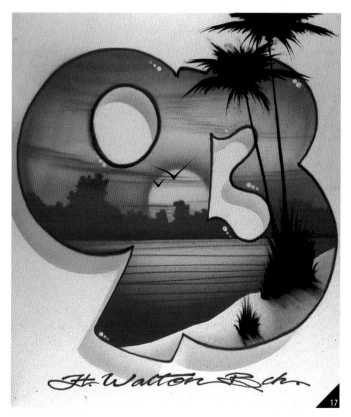

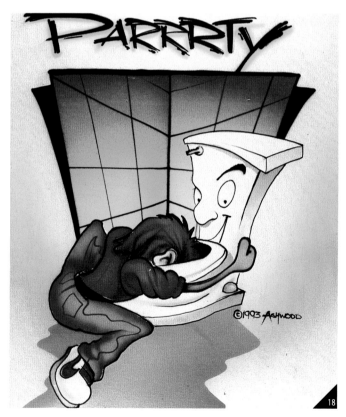

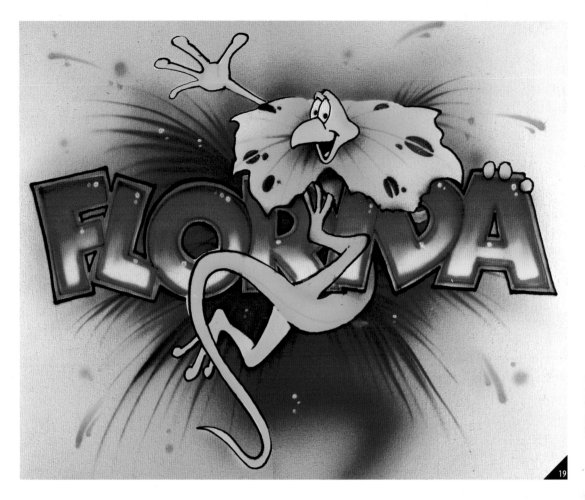

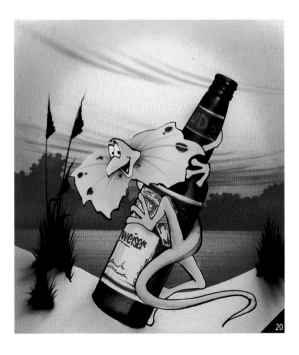

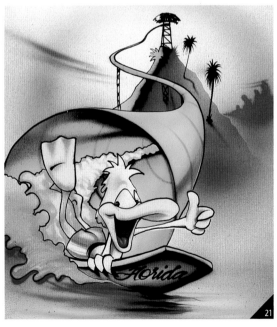

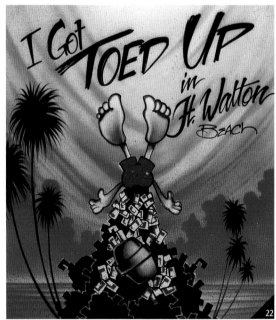

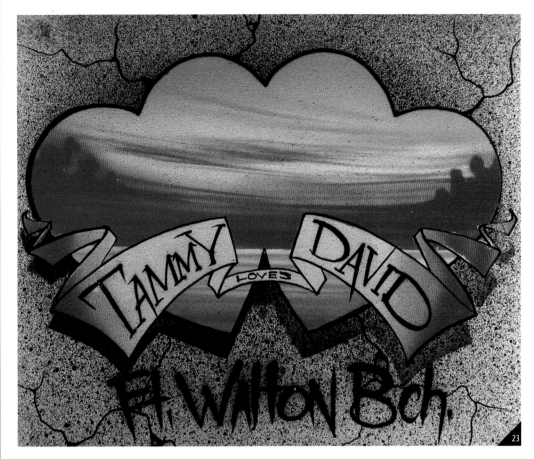

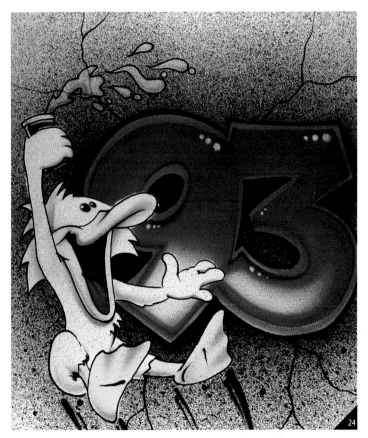

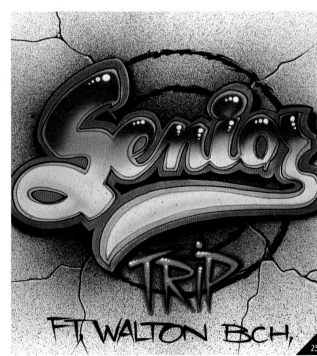

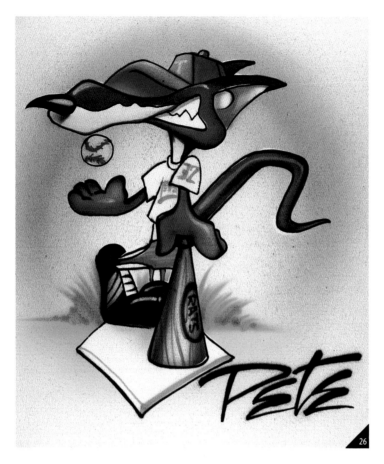

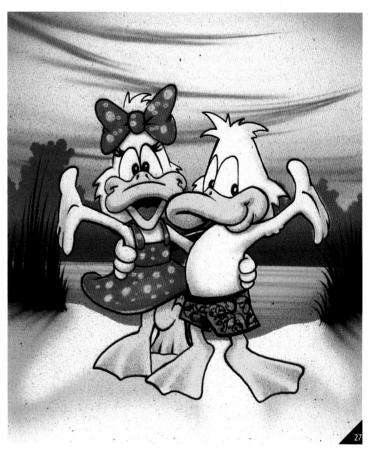

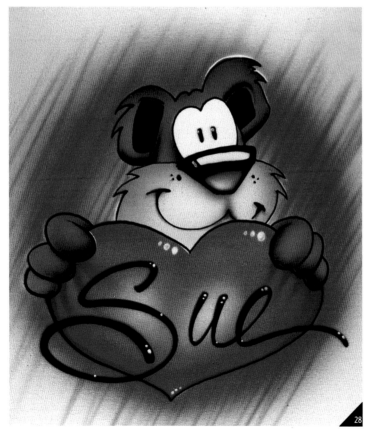

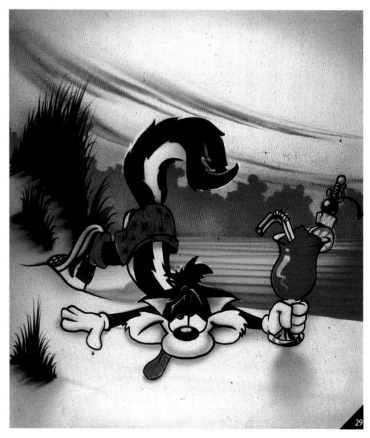

FITZG

SCOTT

SCOTT FITZGERALD

An airbrush artist widely acclaimed for his T-shirt photorealism, Scott Fitzgerald of Panama City, Florida, began airbrushing in 1977. From there Fitzgerald moved on to doing State Fairs for Cowdrey Concessions, then returned to Panama City. His future plans include illustration and owning his own T-shirt and silk-screening business. Scott has earned a reputation for his remarkable ability to airbrush cars freehand in perfect proportion.

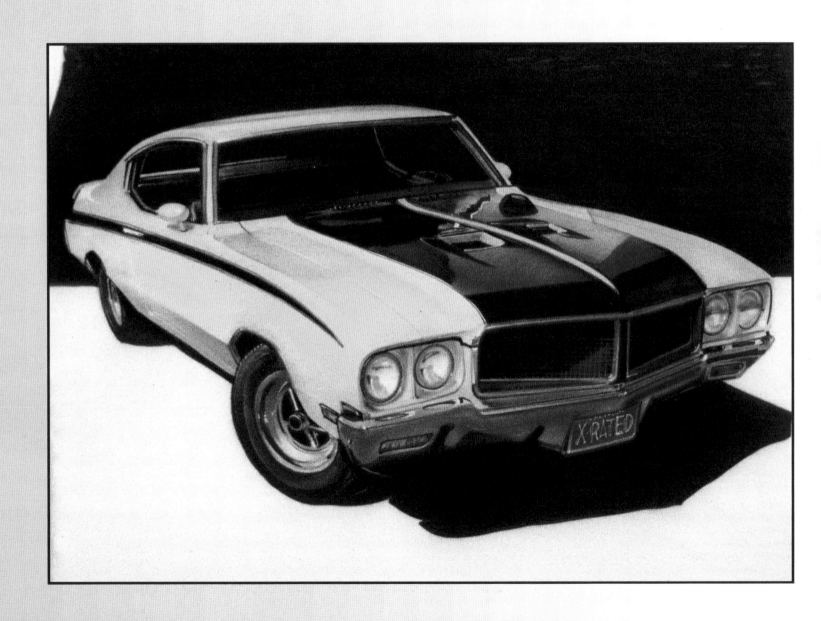

CUSTOM CARS

Next to celebrity portraits, cars are the best way to show off your artistic ability. Even if you're not a Rembrandt when it comes to doing cars, you should still incorporate a few in your display. Car enthusiasts are everywhere, and painting cars will not only drive you to do better custom work, it will impress people that you are in fact an "artist", and not just a novelty craftsman. Your customers may not swamp you with detail work, but you'll gain their respect and confidence in you as an artist.

When painting your display, I suggest leaving out exotic cars. Paint the cars you see in the streets of your area on any Friday night. The multi-gun method that I use to airbrush cars on T-shirts works well. Re-working areas is not a problem, and it actually encourages perfectionism.

TOOLS:

PAINT:
Aqua-Flow Airbrush Paints
AIRBRUSH:
Paasche VL airbrush
AIRBRUSH COMPRESSOR:
Sears 5 Horsepower Compressor
VENTILATION:
Natural
HEAT PRESS:
Hix Heat Press

STEP 1. Sketch a reference image onto the shirt. Here, the left headlight is at the center of the car and should be placed at the center of the shirt.

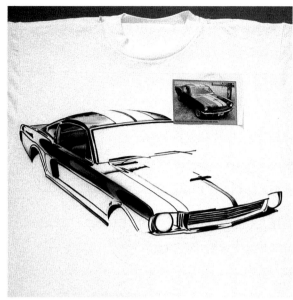

STEP 2. Start with the black. You can see how it progresses from hard line to shading in the areas between the lines. Because the car is black, the shadows should be done in the true color of the car. If the car were red or yellow, the shadows should be done in brown or purple respectively.

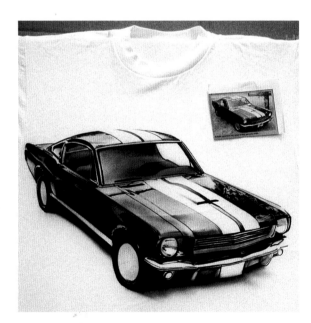

STEP 3. The black shadows are done. Minimize any overspray by constantly cleaning the tip of the airbrush. You need fine, clean lines to paint fine, clean cars. Follow the reference piece exactly as you see it. Pay close attention to slight changes in color and hue. Blue is added over the black base to create a rich, shiny feel. Purple is also in the reference so I made sure to paint it on the shirt.

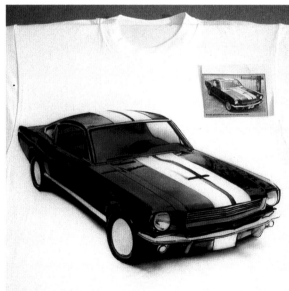

STEP 4. Faded green on the underside of the bumper reflects the color of grass.

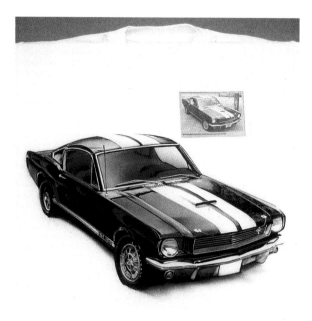

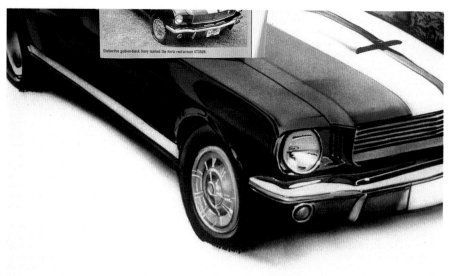

STEP 5. To create the wheels, mist black to make a gray tone and gesture in the shadows. Lightly fade blue over the gray to suggest sky reflecting from the rims. Work close to the surface of the shirt to chisel out highlights in the rim, the headlights, and the bumper.

STEP 6. With black in hand, touch any obvious white overspray. The trim on the windshield, the rim on the door, and the grill were all worked with white, then worked with black, and then reworked with white again. This reworking gives the chrome a crisp, polished look.

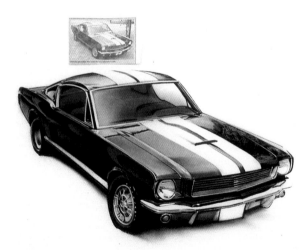

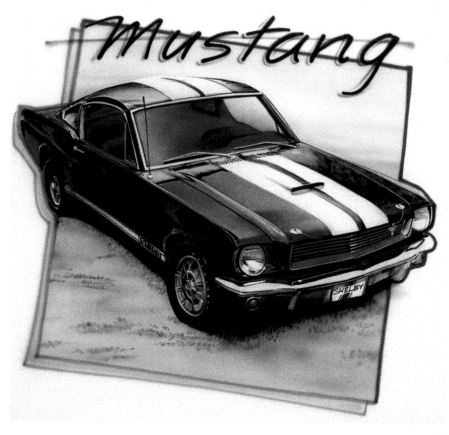

STEP 7. Paint in the background. Try to keep it simple to avoid cluttering up the picture. Touch up any highlights that need work, then add the license plate, door handle, and finishing details.

STEP 8. The multi-gun system refines the finished product; making it easier to rework areas, and encouraging a perfectionist attitude.

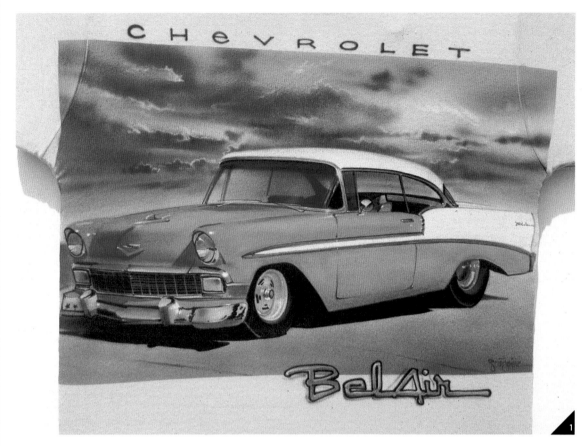

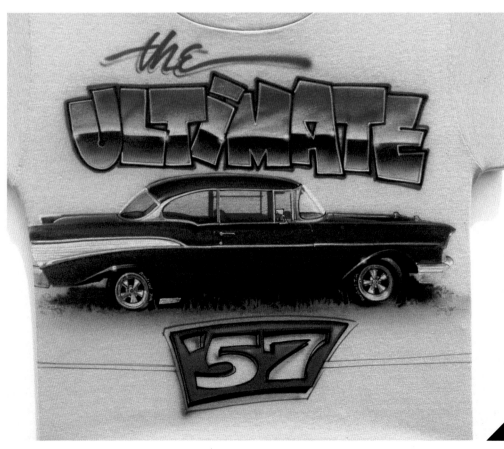

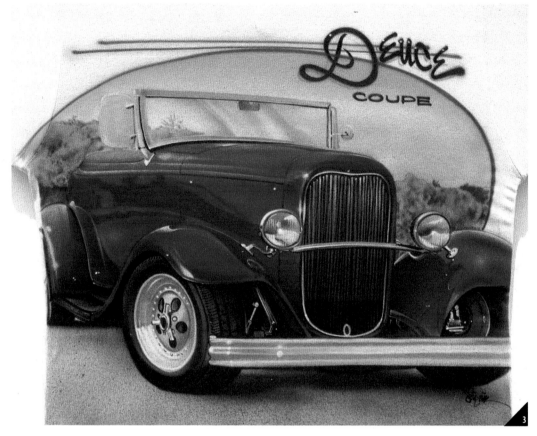

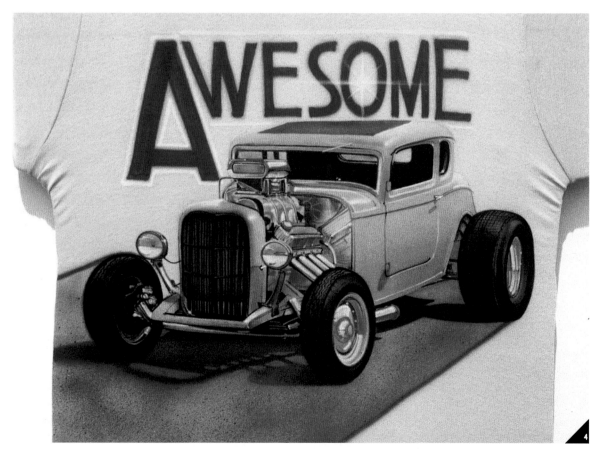

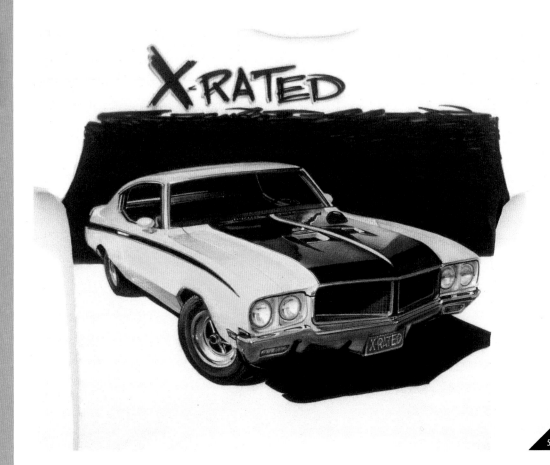

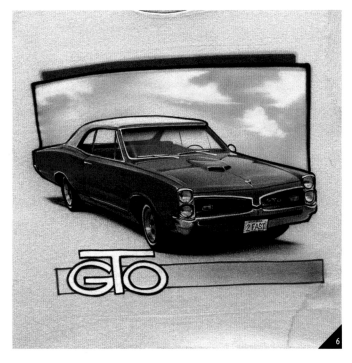

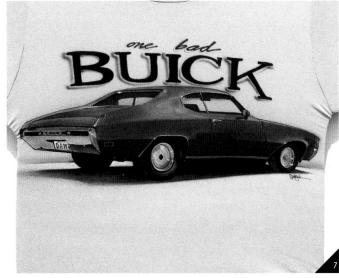

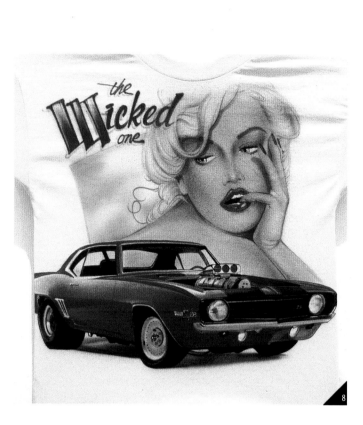

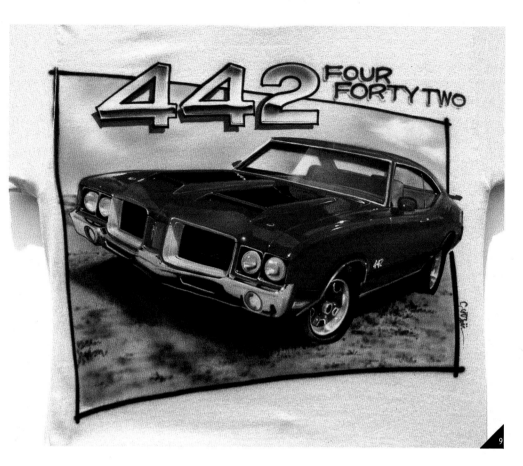

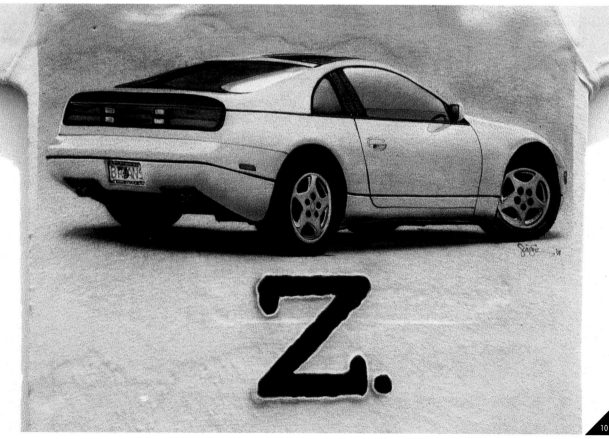

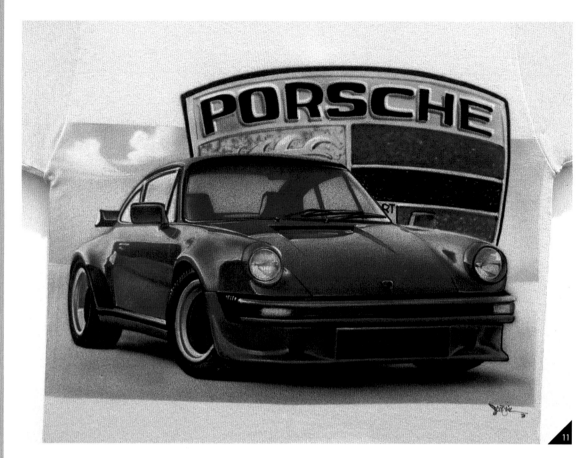

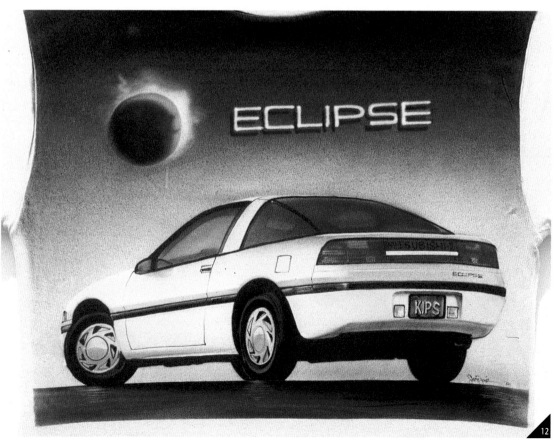

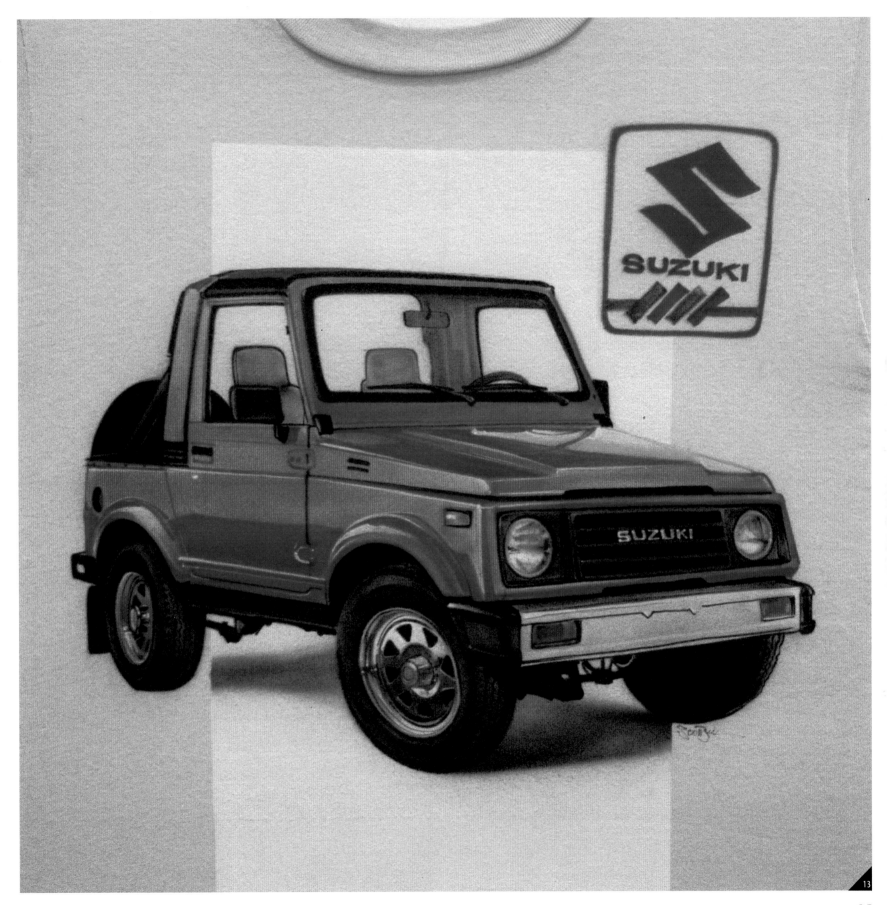

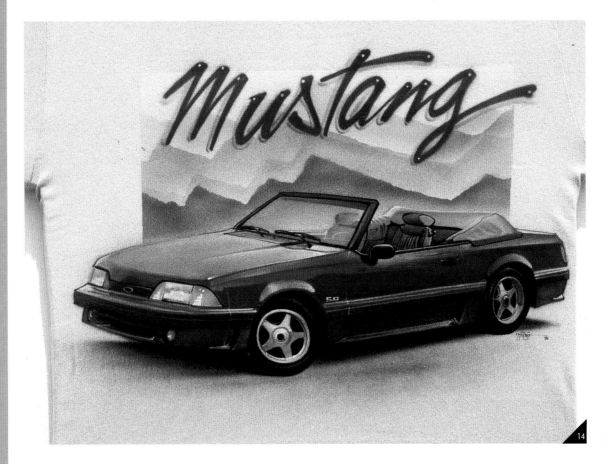

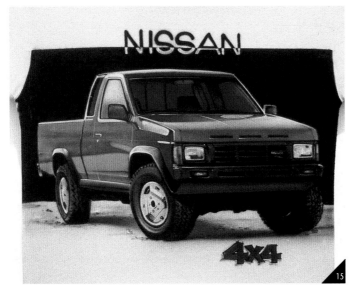

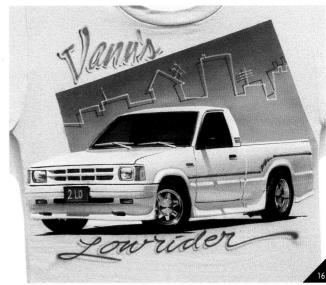

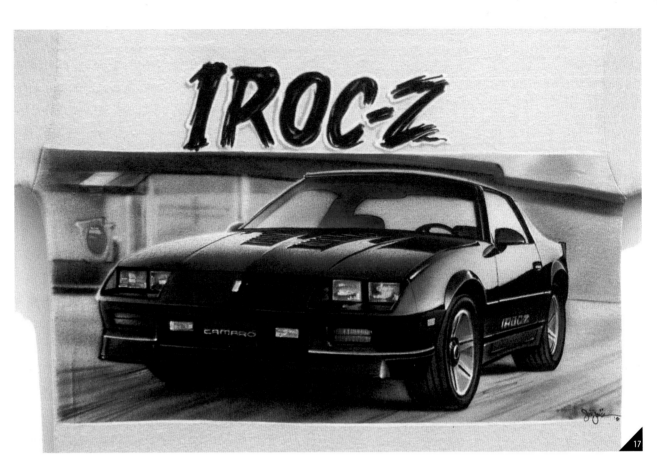

17

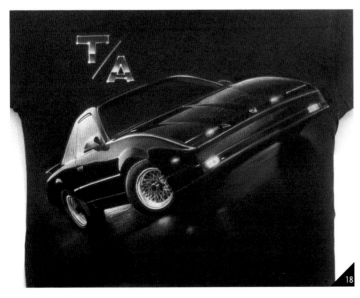

18

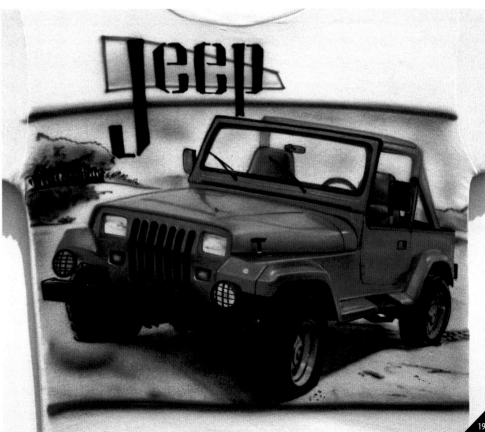

19

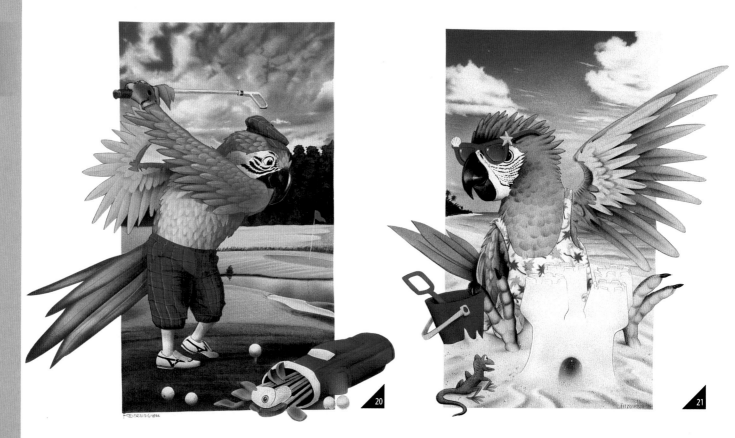

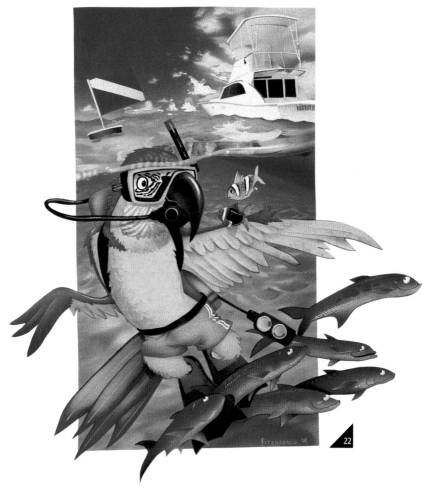

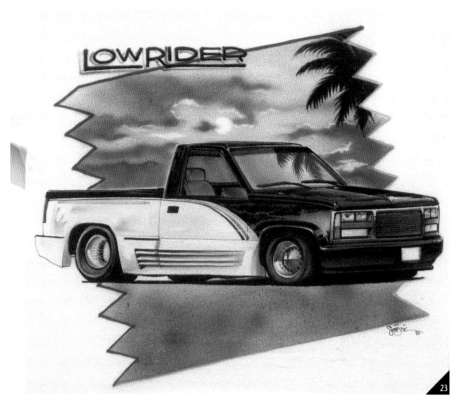

LOWRIDER

23

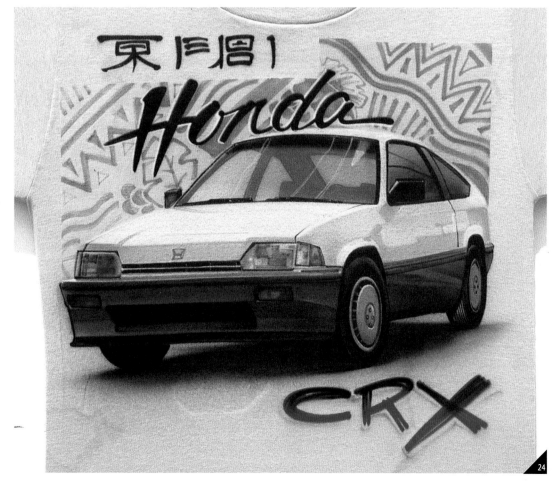

東戸冨1 Honda

CRX

24

JÜREK

Jürek was born in Breslau, a town in southwest Poland whose heritage and history stretches back to the early Middle Ages. Jürek can trace much of his passion for art to his native city. Many years after moving to America, Jürek worked the Florida mall scene and finally settled in Provincetown, Massachusetts, where he developed his trademark portrait style. Jürek's portrait work is unsurpassed; he has become famous for his ability to transform blank cloth into Albert Einstein, Keith Richards, or even Salvador Dali.

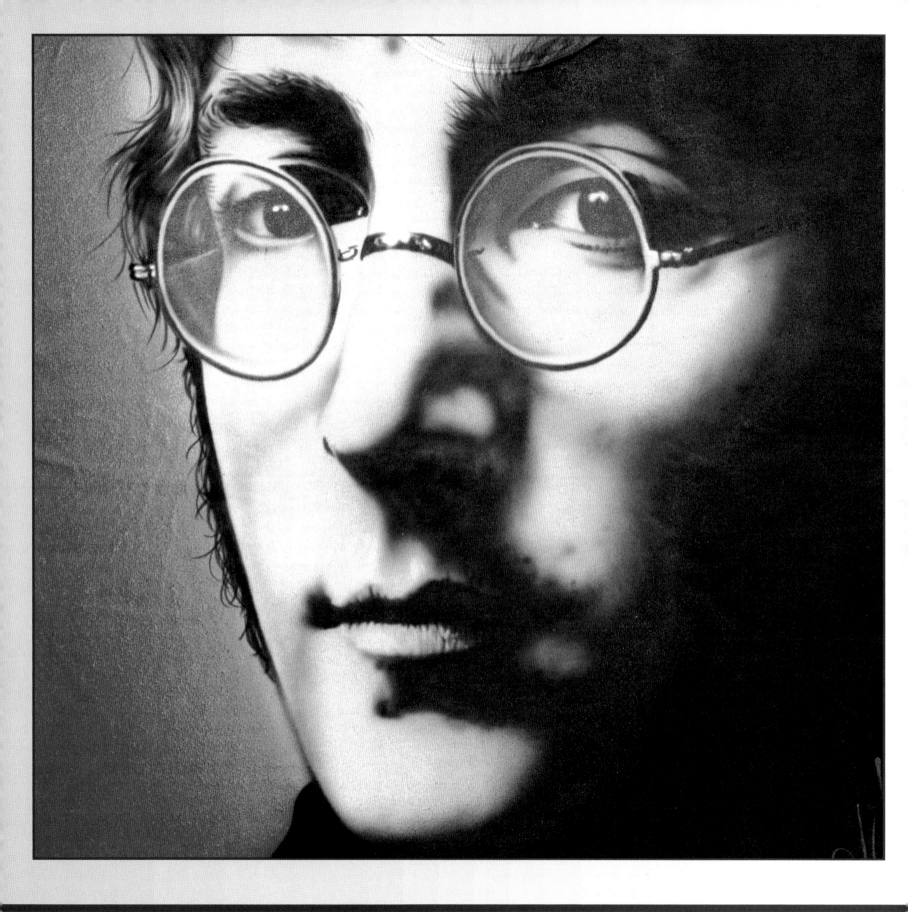

WILD CATS

Art should project your beliefs, your personality, and not be used as a tool to satisfy the market culture. Wildlife Art is one of the most dynamic and fastest growing forms of T-shirt airbrush art. This art form also delivers a message of political importance to the world. Wildlife art brings the issues of extinction and environmental protection to the attention of the public.

The subject matter of this piece is a reflection of my philosophy and politics. Airbrush artists fill a very human need; that of expressing personality through fashion. The section that follows demonstrates techniques for creating a realistic portrait of a tiger. In painting animal portraits, light and shadow help to create the illusion of form and texture. It is my hope that you will finish this book with a strong urge to improve your standards concerning the whole wearable art scene.

TOOLS:

PAINT:
Jürek Professional Textile Colors
AIRBRUSH:
Iwata HPBC (for colors) *Iwata Custom Micron SB (0.18mm)
AIRBRUSH COMPRESSOR:
Hansa Classic 50A Compressor
VENTILATION:
Respirator
HEAT PRESS:
Hix Heat Press
Good Music

STEP 1. Fill a pump spray bottle with equal parts water and Extender Base and spray the entire front of the T-shirt. Let the shirt dry to the touch, then iron or heat press it for about 30 seconds at 350 degrees. This will compress the lint on top of the fabric. Use light gray pastel to draw a faint outline of the animal on the garment. Cover the image with short strokes of opaque white, strictly following the angle or direction of the animal's fur, to create the foundation for a three-dimensional form.

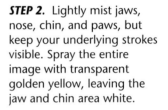

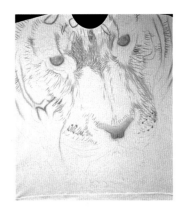

STEP 2. Lightly mist jaws, nose, chin, and paws, but keep your underlying strokes visible. Spray the entire image with transparent golden yellow, leaving the jaw and chin area white.

STEP 3. Spray transparent orange around the eyes to "sculpt" the image and to create shadows around the eyes and nose. Leave a few random, short strokes over the nose, mane, and jaws.

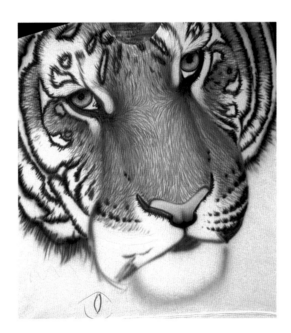

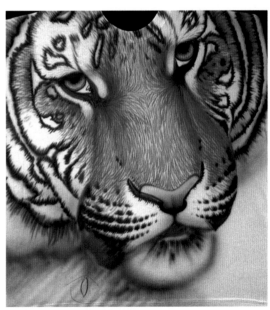

STEP 4. Add a glaze of dark brown or burnt umber to the dark areas, further defining the shadows and adding dimension. Again, leave a few random strokes showing on other parts of the head, but concentrate most on the depressed areas.

STEP 5. To deepen the color of the shadows, mist the dark brown areas with opaque black. Define some of the details in the nose, jaws, and eye areas with the same color. Place a few fine strokes to enhance the texture of the fur.

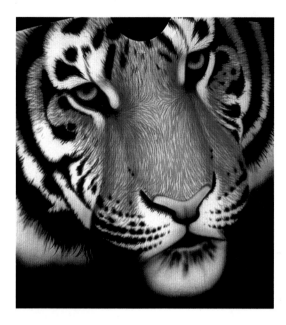

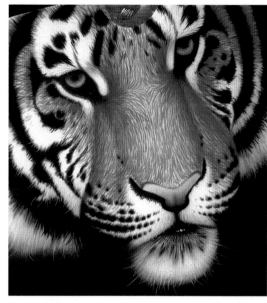

STEP 6. Paint very fine strokes of opaque white on the points where the strongest light hits, namely the eyelids, nose, and jaws, to further characterize a sense of dimension. For this step the Iwata Micron airbrush is recommended. Next, haze these areas with golden yellow, again leaving white areas under the nose and chin.

STEP 7. Paint a few whiskers with black, then paint the rest of them with white, overlapping into the black ones. Darken the roots of the whiskers with black to make them appear more realistic.

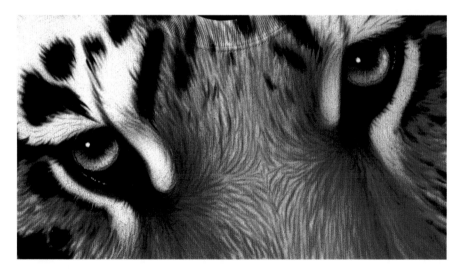

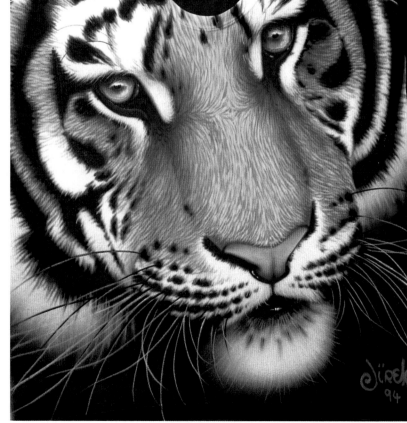

STEP 8. Finally, carefully add small, realistic white highlights around the nose, eye, jaws, and chin.

JÜREK

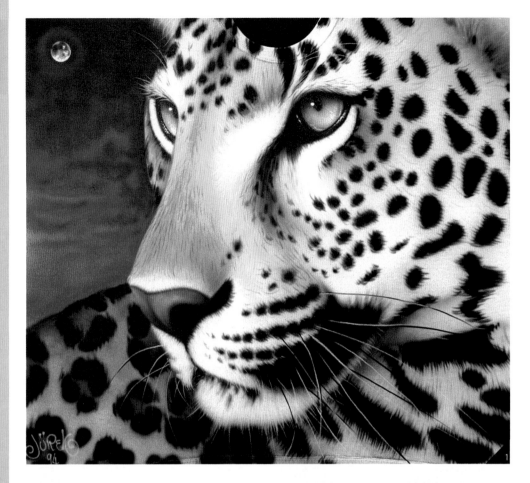

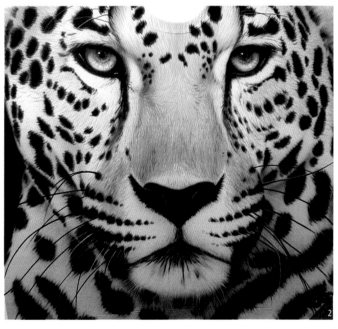

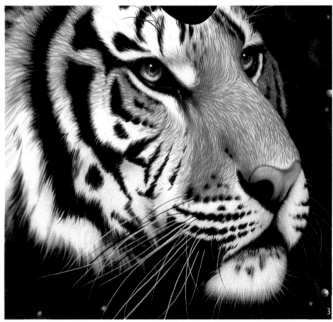

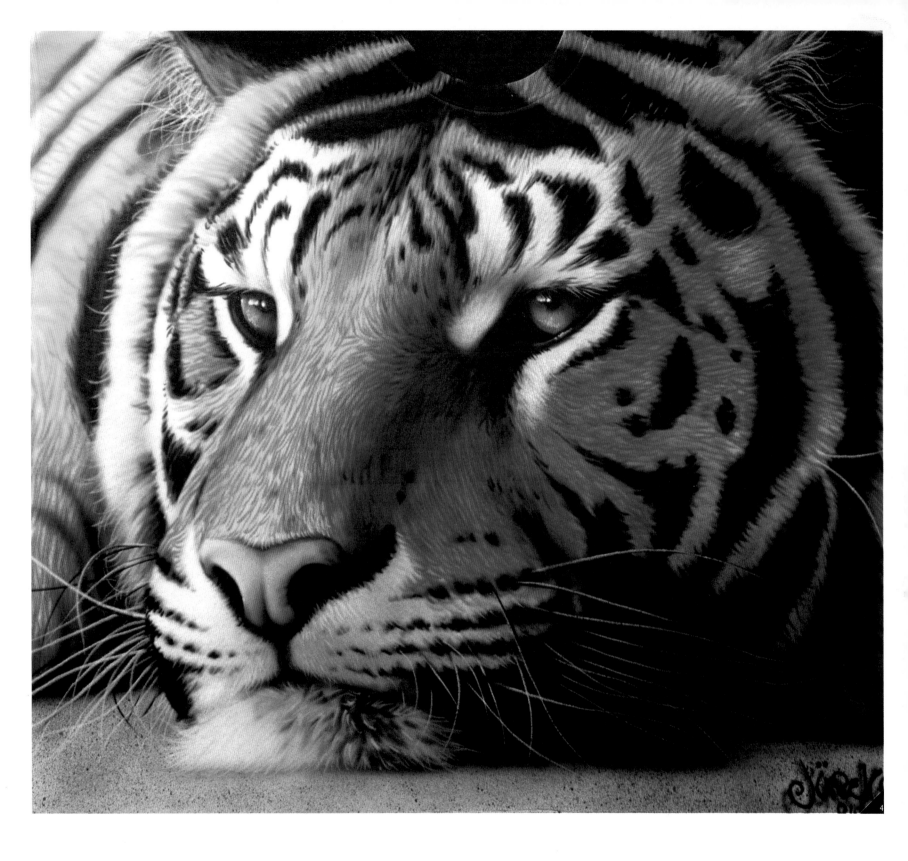

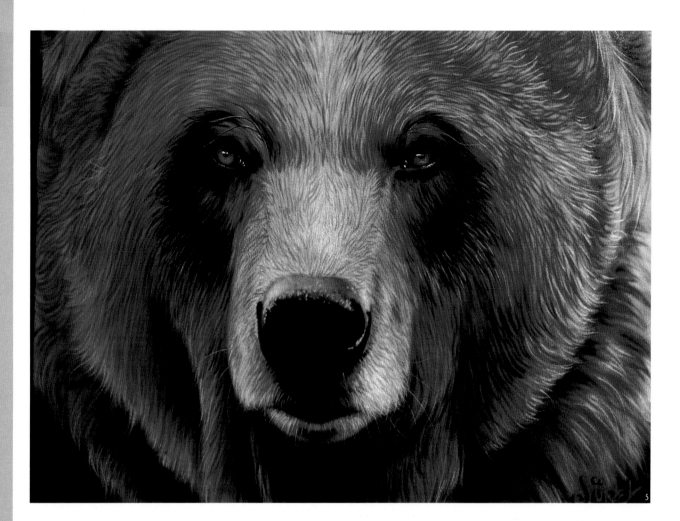

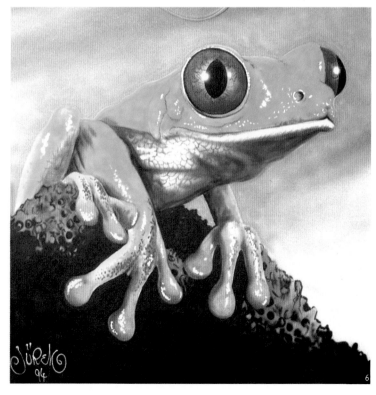

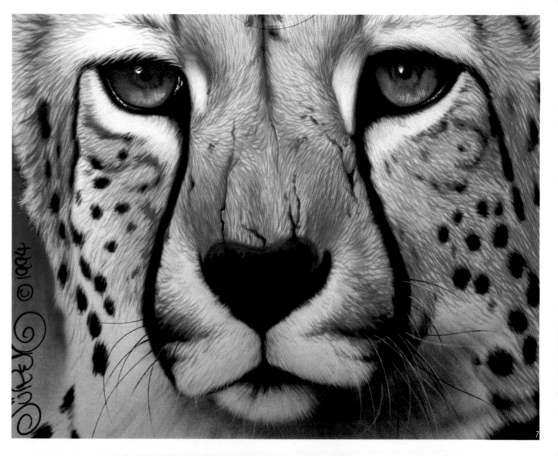

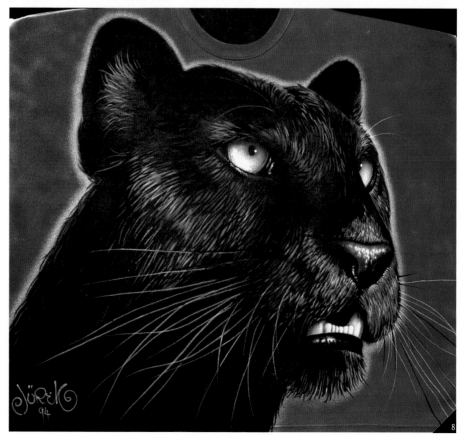

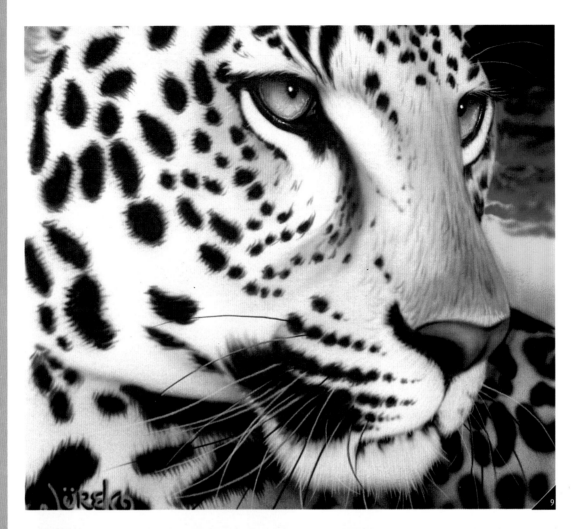

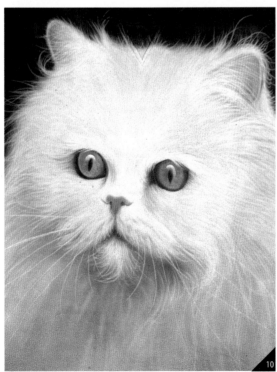

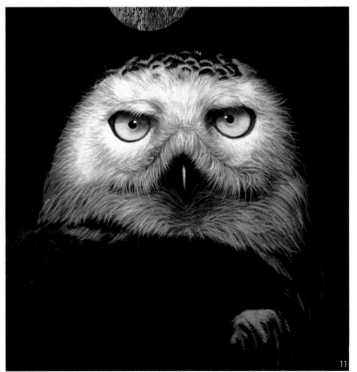

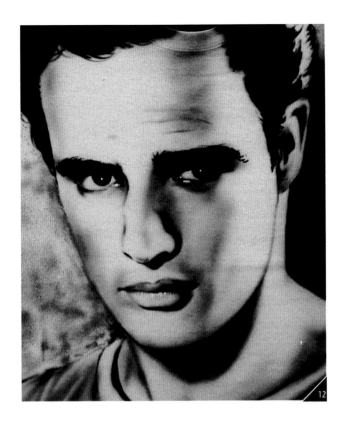

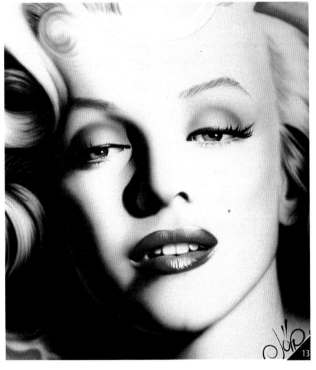

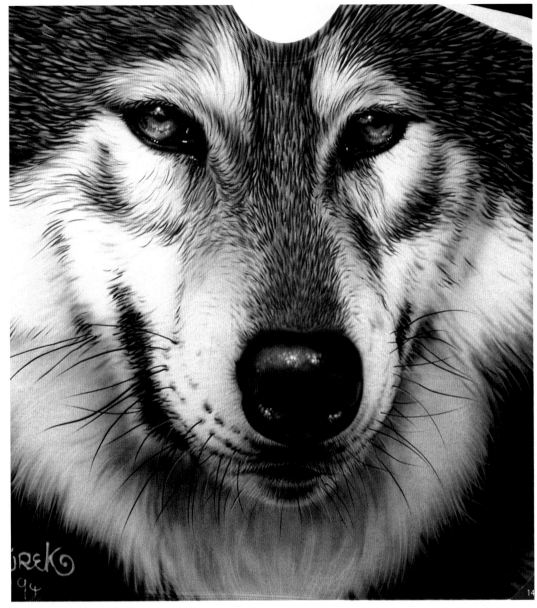

JÜREK

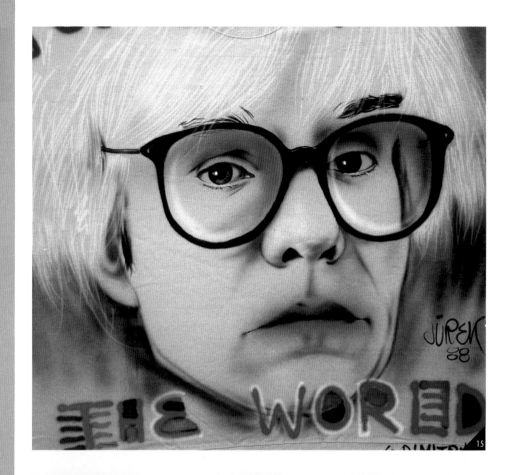

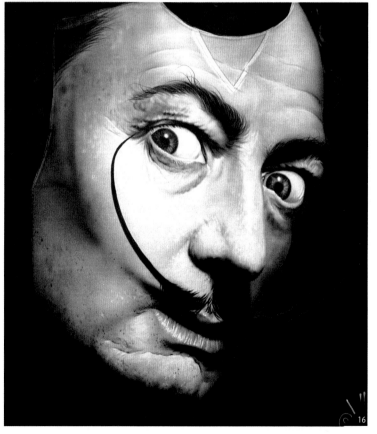

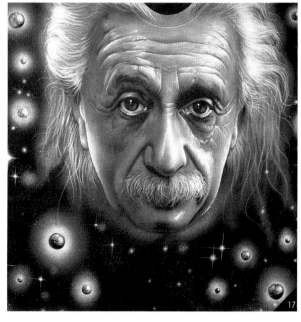

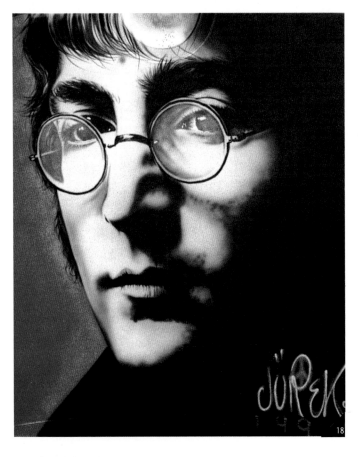

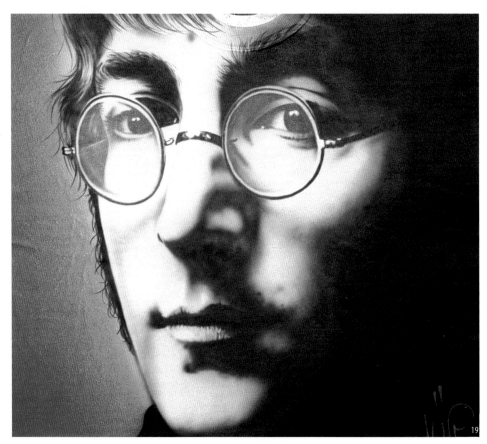

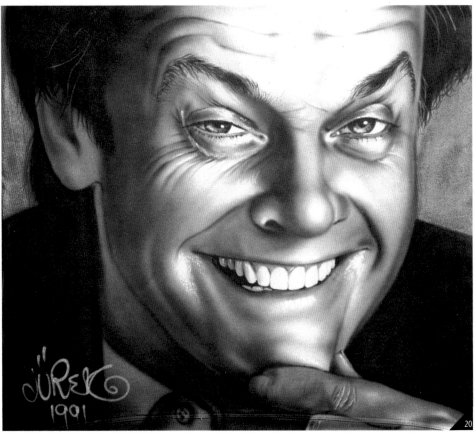

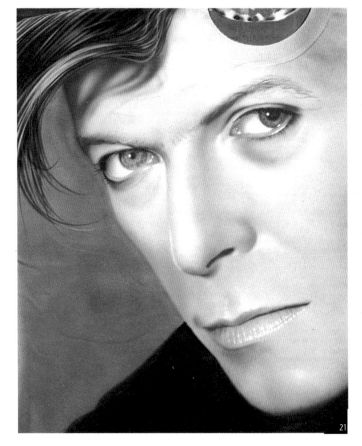

JÜREK

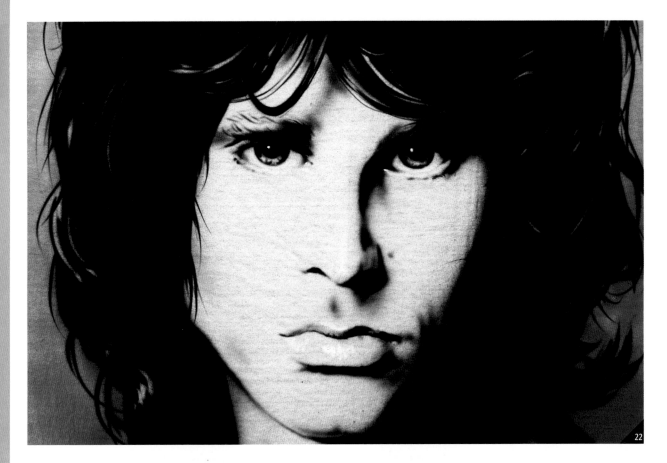

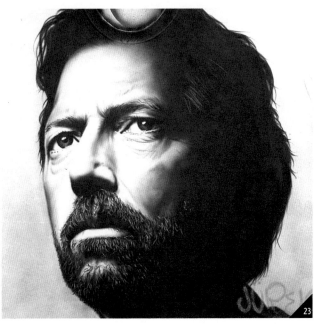

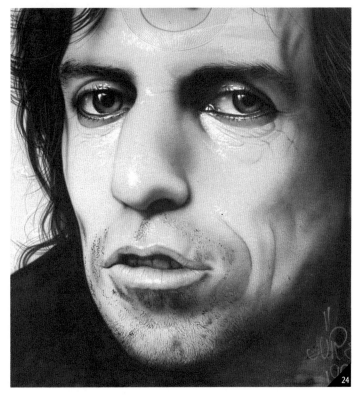

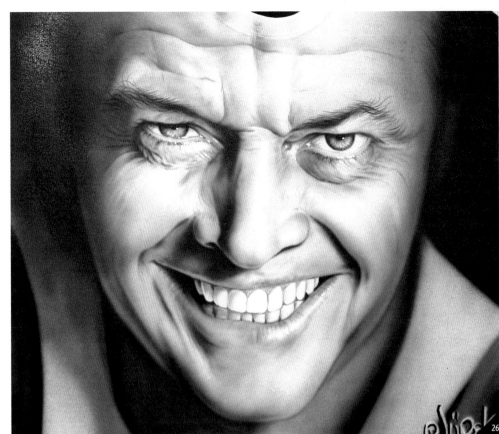

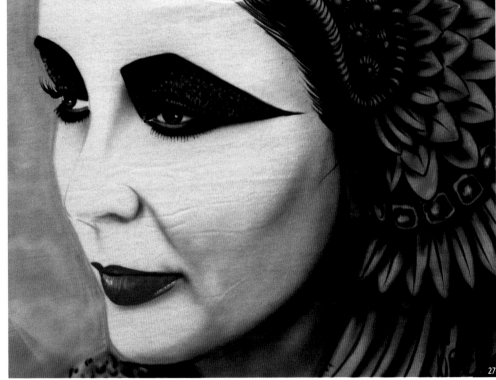

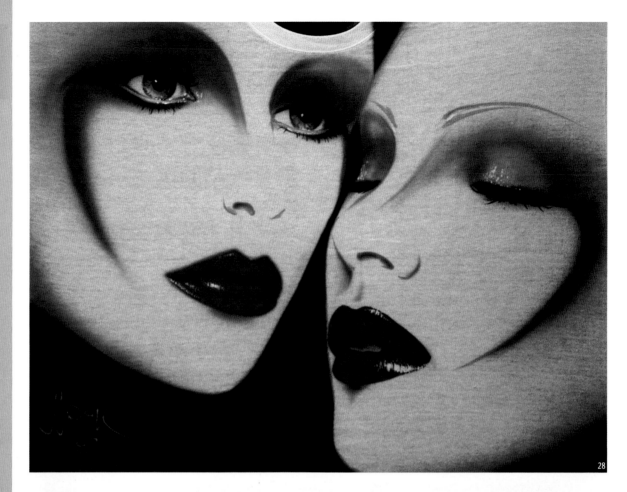

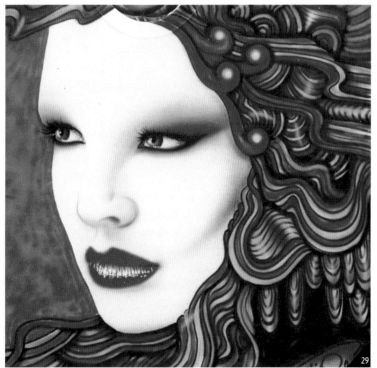

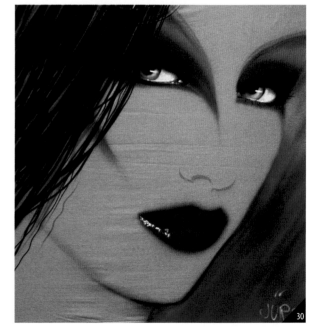

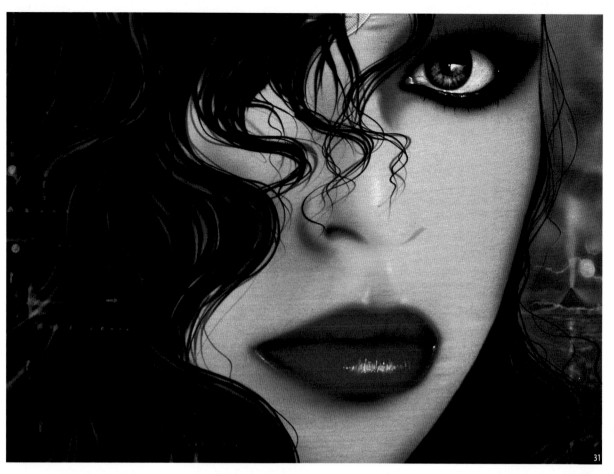

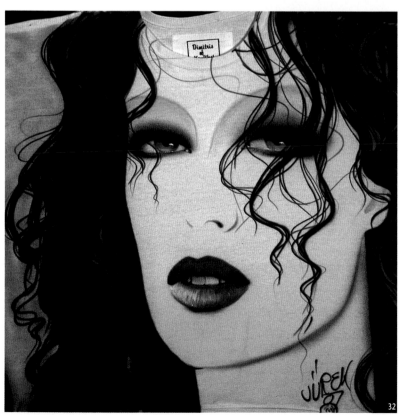

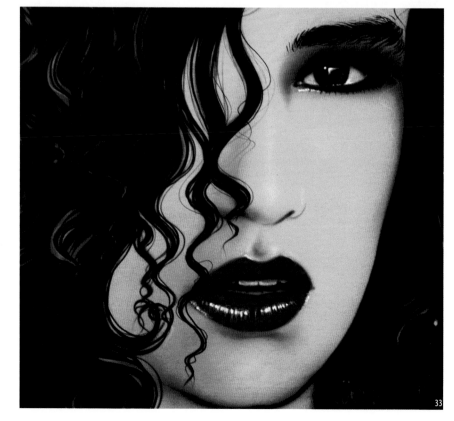

HILL

TERRY

TERRY HILL

Terry Hill has been airbrushing since 1981 and has become one of the most recognized names in T-shirt airbrushing. A frequent contributor to Airbrush Action magazine, Hill is also a design consultant to Createx paints, Thayer and Chandler, and the Silentaire company. Hill lives in Fort Walton Beach, Florida, and operates Hot Air with Don Ashwood during the summer months. The artist has made 10 airbrush-instruction videos to date.

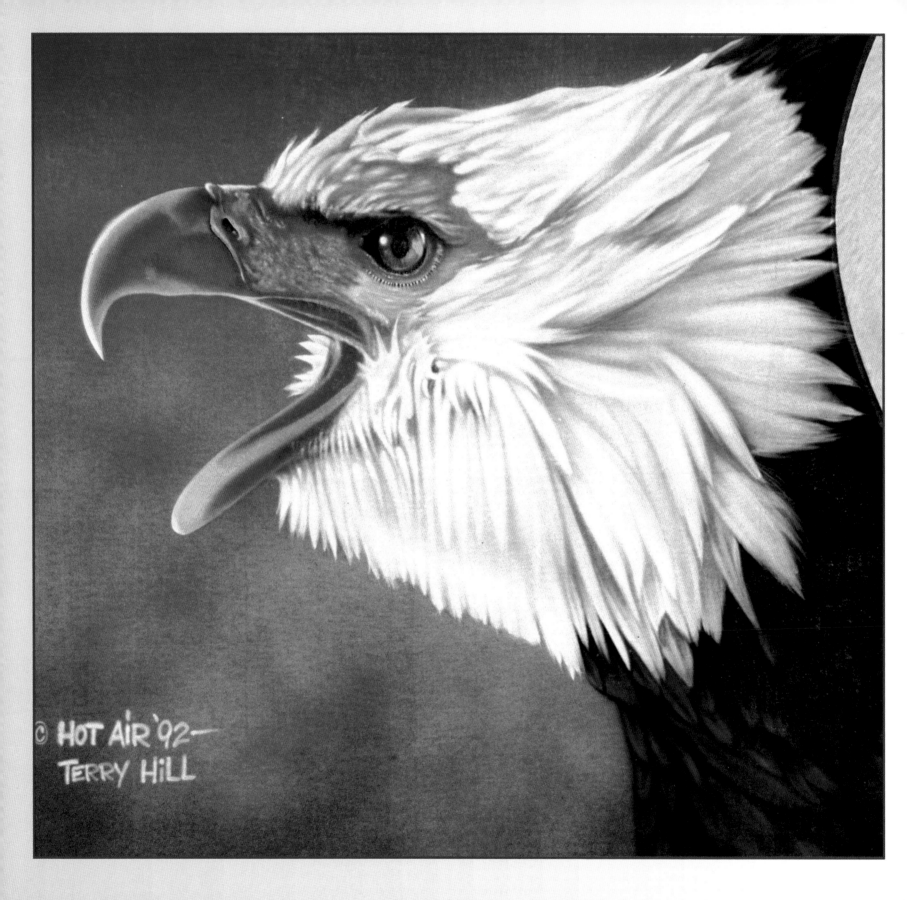

PAINTING WITH A PROJECTOR

My intent in creating this how-to of a gorilla is not only to demonstrate the technical aspects of creating realistic fur, but to motivate you to paint with compassion for your subject. Gorillas are threatened by a loss of habitat, and mountain gorillas are the most endangered, with less than 400 estimated alive in the wild today.

In this decade, killing animals is out, saving animals is in, and painting animals is fantastic.

I start with a pencil sketch, which I complete using an opaque projector. When projecting the image, I use a mapping technique on the sketch. I shade in the areas that will be painted dark, rather than just making an outline. This technique maps the different values and helps me locate details in the later stages of the painting.

TOOLS:

PAINT:
Createx Transparent Airbrush Colors
AIRBRUSH:
Thayer and Chandler's Vega 2000 Airbrush, Iwata HP-BC 2 (for detail), and Olympos HP-25BC
AIRBRUSH COMPRESSOR:
Terry Hill Professional model compressor by Silentaire
VENTILATION:
Ventilation system built into easel
HEAT PRESS:
Hix HT400 Heat Press

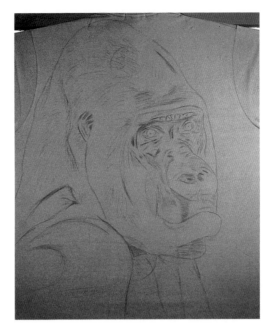

STEP 1. Start with a pencil sketch. The sketch may be completed with the use of an opaque projector and a 6B Ebony pencil. When projecting the image, use a mapping technique on the sketch. Rather than simply outlining shapes, shade the areas that will be painted dark.

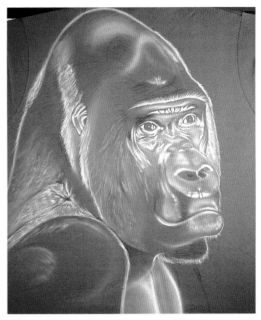

STEP 2. Since the shirt is a dark color, begin the painting with opaque white. Using the pencil sketch as a guide, pay close attention to the reference photo and lay in a good foundation to build upon for painting the transparent colors later.

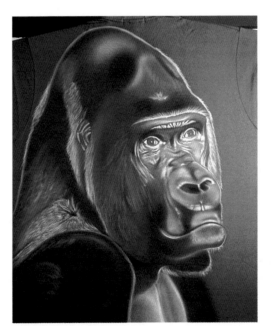

STEP 3. Start adding in color. Since the majority of this painting will be completed with transparent colors, it may be necessary to do an underpainting. Before choosing colors for an underpainting, study the reference closely and try to match its undertones. In this case, violet is used to establish the deepest shadows and to tint some of the white base painted in Step 2.

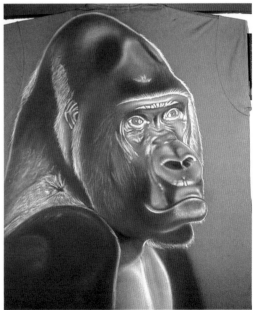

STEP 4. Spray a coat of deep red over various parts of the fur. Be careful to stay true to the reference; if you don't see the color there, don't add it to the painting.

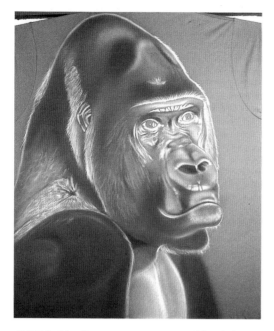

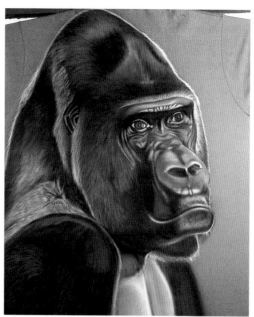

STEP 5. Use fluorescent orange to blend the violet and red together. Fluorescent paint, when used correctly, warms up a painting. However, if it is overdone, fluorescent paint looks unnatural and quite out of place. At this stage, the painting is somewhat odd looking, but it all comes together in the next step.

STEP 6. Apply deep brown in short, crisp, dagger-like strokes and soft fades to the furry areas. Creating realistic fur is a building process; pay careful attention to the length, texture, and flow of the fur. It is also important to follow the shape of the body and accent its underlying muscle structure. Notice that the original violet underpainting is no longer visible, but its influence is still seen through the transparent brown placed on top of it.

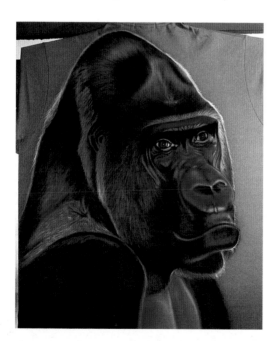

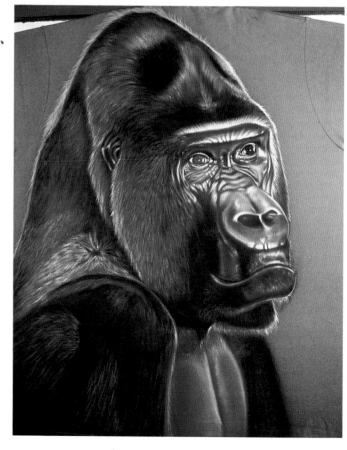

STEP 7. One of the interesting aspects of this painting is the blue light cast on the face and chest of the animal. Pthalo blue should be applied extensively in these areas and the dark shadow areas.

STEP 8. Detail can now be added using opaque white. Remember to pay close attention to the texture of the fur. In the push and pull of light and shadow, the proper use of white can make or break a painting.

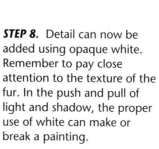

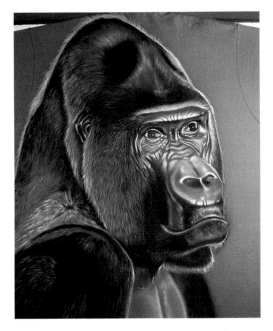

STEP 9. Lightly spray yellow in areas such as the brow and the cheeks to warm the highlights.

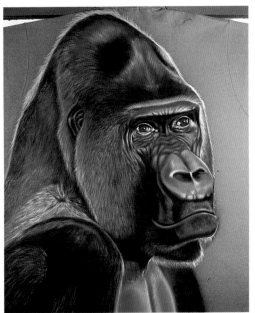

STEP 10. Use violet to subdue some of the highlights in the face and to shadow the back of the head and the cheek. Then overspray the chest and face with pthalo blue and blend in the yellows and oranges in the fur with hot pink. Take great care in painting the eyes; they establish the personality and emotion of the person or animal being painted. Finally, add black to help sink the nostrils and to give detail to the ear and brow bone.

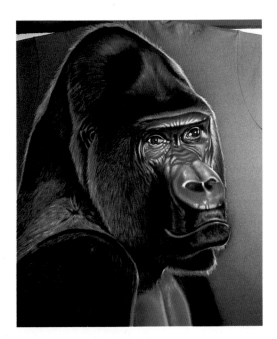

STEP 11. Using opaque white, correct the shading and highlights on the face.

STEP 12. Notice the minimal use of black, the texture development in the fur, and the colored highlighting found even in the shadowed areas under the brow bone.

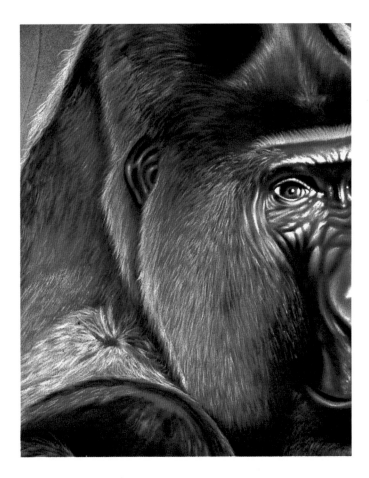

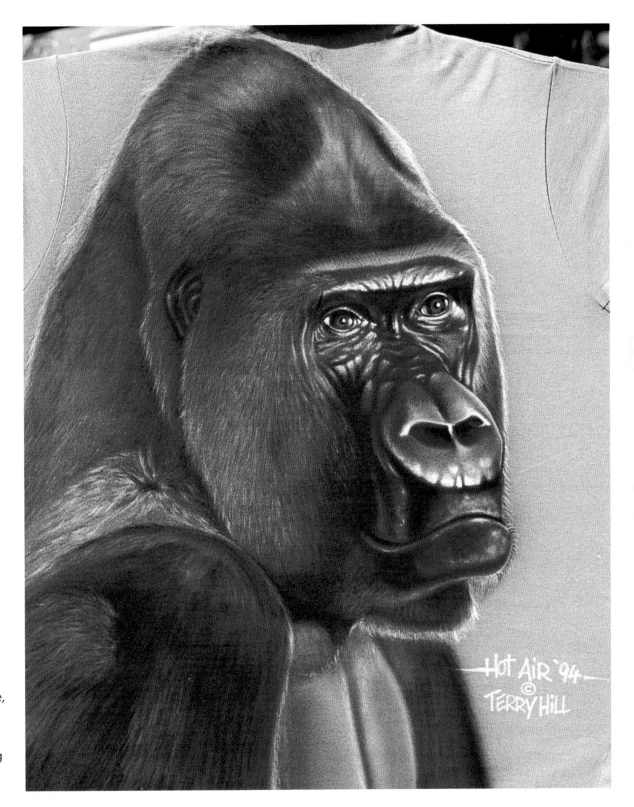

STEPS 13. The finished product. You may not always have a dramatic statement to make, such as painting an animal on the verge of extinction. You may simply be painting someone's housepet. Focus on the animal's eyes. If you can capture the emotion or feeling in an animal's eyes, your painting will be realistic and lifelike.

CHEAP TRICKS: GRANITE

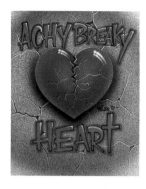

The Stippling method I use to create the stone or granite effect involves deflecting the paint off just about any object you can hold conveniently in your hand, such as a clothespin or a tongue depressor. This method will work with any airbrush (the Aztek offers a splatter nozzle that produces a similar effect but, it tends to work better at low pressures and with thin paints), and you can be creative here. I've seen people use everything from broken plastic spoons and knives to the end of their thumbnail.

The beauty of this method is that you don't have to change your normal air pressure. Personally I set my compressor to about 65 psi.

This technique can be messy until you master it, so you'll want to wear something that you don't mind getting a little paint on, and be sure to throw a drop cloth on the floor.

STEP 1. The broken heart is drawn on poster board or your stencil material of choice and then cut out. We will use both the positive (the piece you will be spraying around) and the negative (the piece you will be spraying into) of this stencil, so be careful to keep both pieces in good shape.

STEP 2. Place the stencil positive onto the shirt.

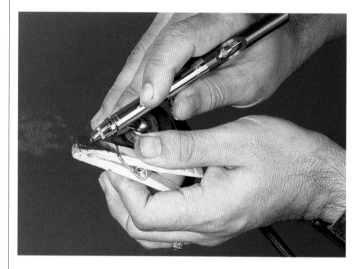

STEP 3. This is how your airbrush should be positioned on the clothespin. The clothespin serves to direct your aim as well to control the stippling. Generally, if you want concentrated areas of stipple (dots), you'll need to be within 3 to 6 inches of the surface. Press the trigger all the way down for maximum air flow and rock it back slightly to release a small amount of paint.

If you seek a more loosely spaced stipple pattern simply use the same trigger setting as above but hold the airbrush 6 to 12 inches from the surface. Large dot patterns can be produced by backing away as far as 20 to 30 inches or more, fully throttling the finger lever, and experimenting with different amounts of air pressure.

The variables to try and consider are many: air flow, distance from work, amount of paint, thickness of paint, and amount of air pressure.

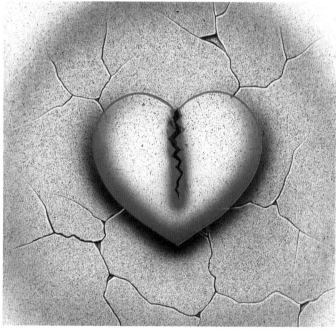

STEP 4. Stipple the area around the stencil positive. Here I've used black, violet, and deep blue. After stippling, and without using the clothespin, I spray the edges to create a soft border. A soft shadow and erratic cracks are added.

After highlighting the cracks with opaque white, the lettering is done using an opaque blue I created by mixing Createx pthalo blue pure pigment and opaque white. The lettering is then thinly outlined in black, followed by a thick hot pink outline.

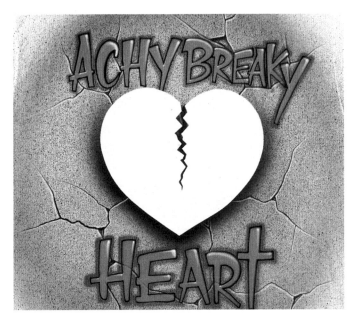

STEP 5. The stencil positive is removed.

STEP 6. The stencil negative is put into place.

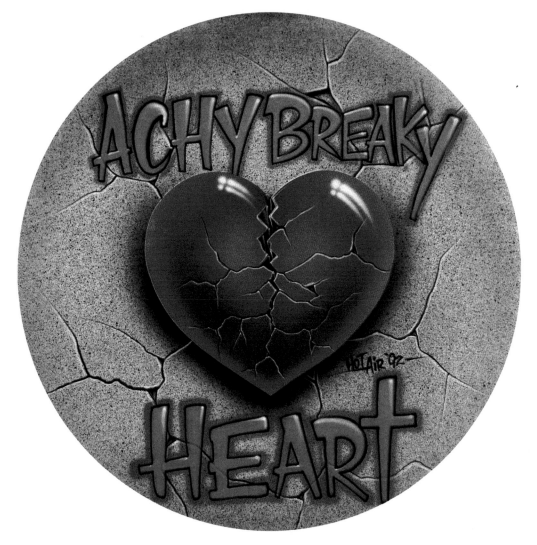

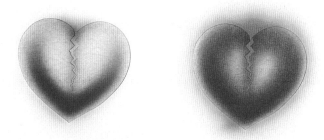

STEP 7. The heart is painted by first using violet as the underpainting to establish tone, followed by layers of red and hot pink.

STEP 8. More cracks are added to the heart along with white highlights and finishing touches.

TERRY HILL

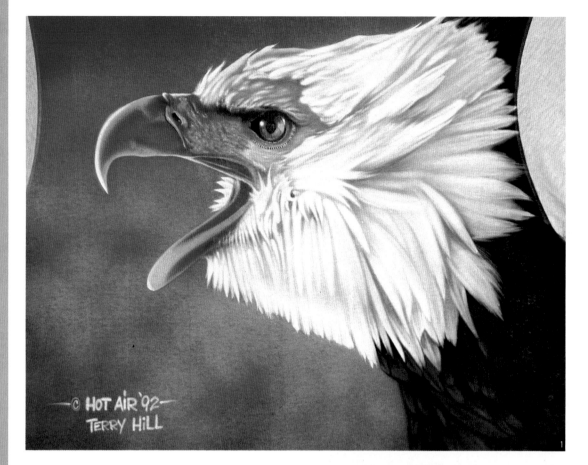

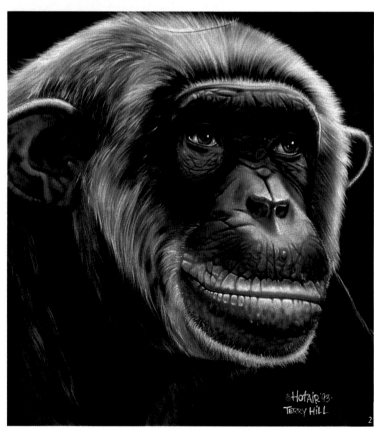

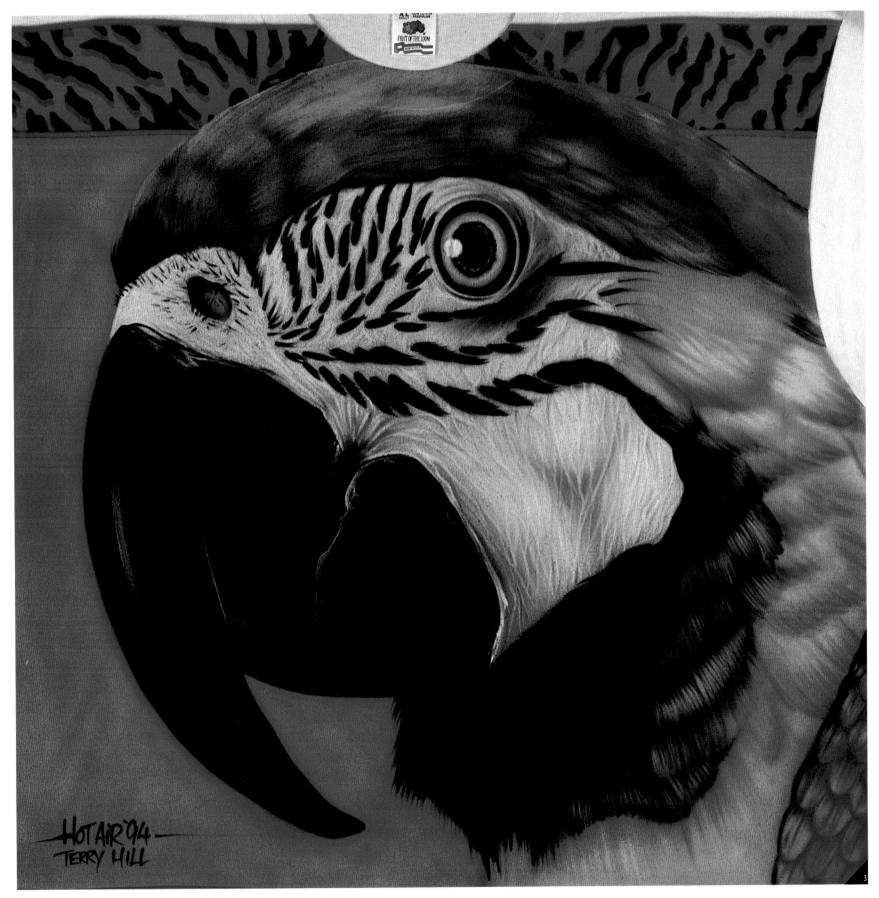

4. Black Convertible
5. Red and White Sports Car
6. Blue Care
7. Air Job Porsche

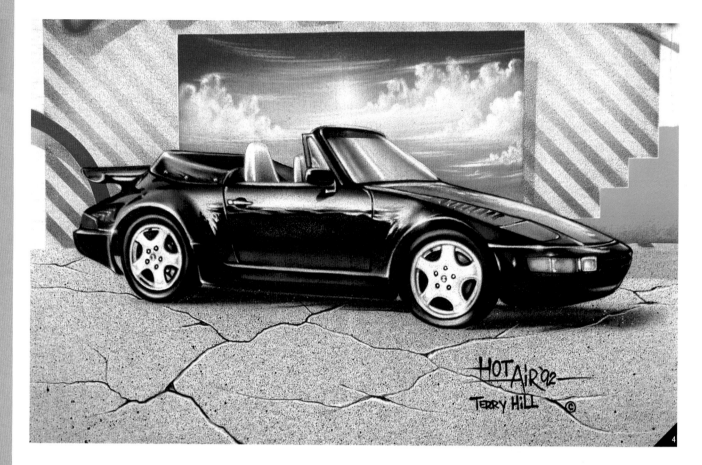

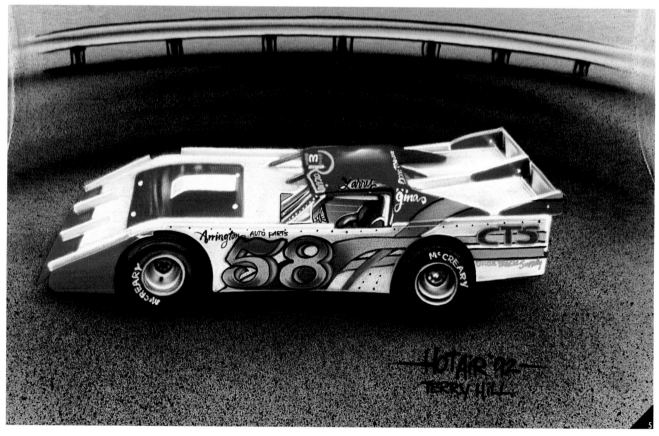

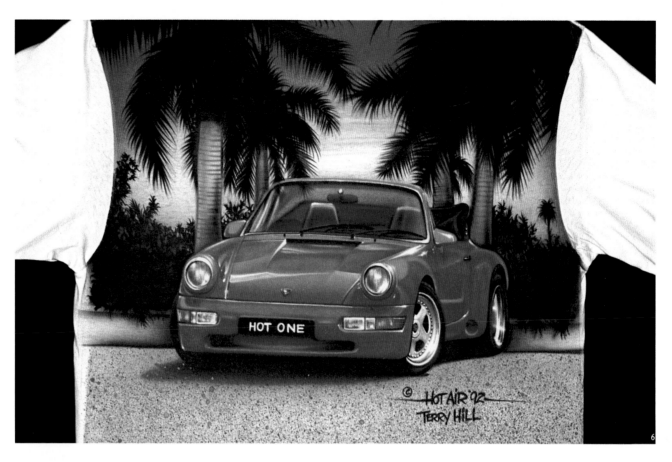

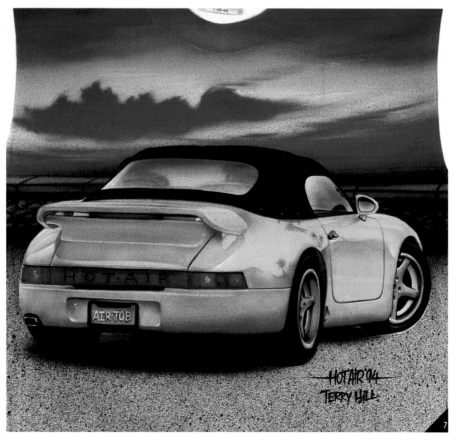

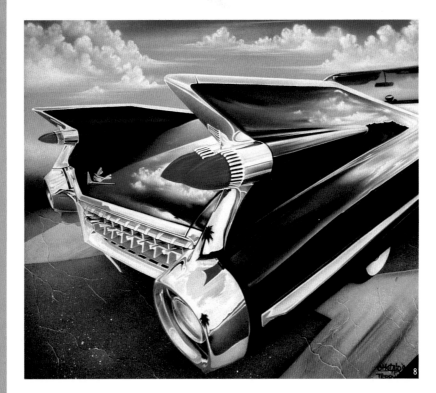

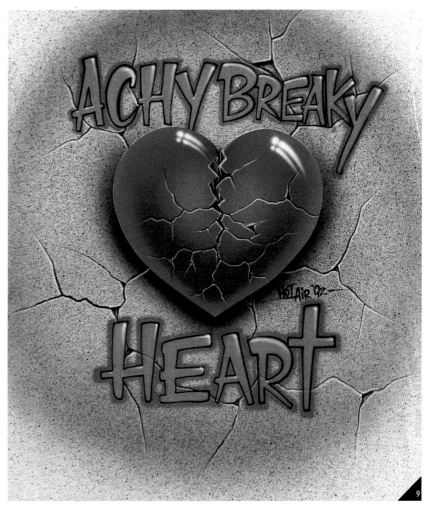

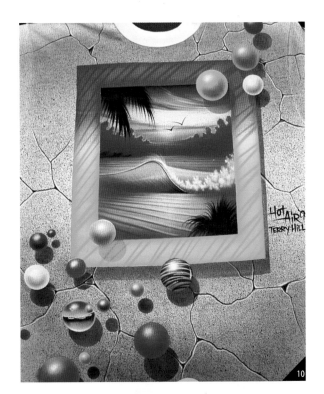

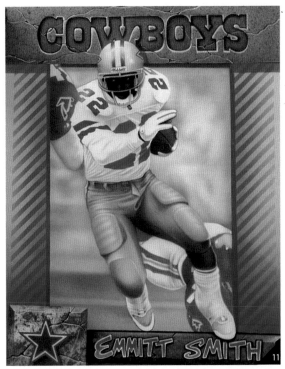

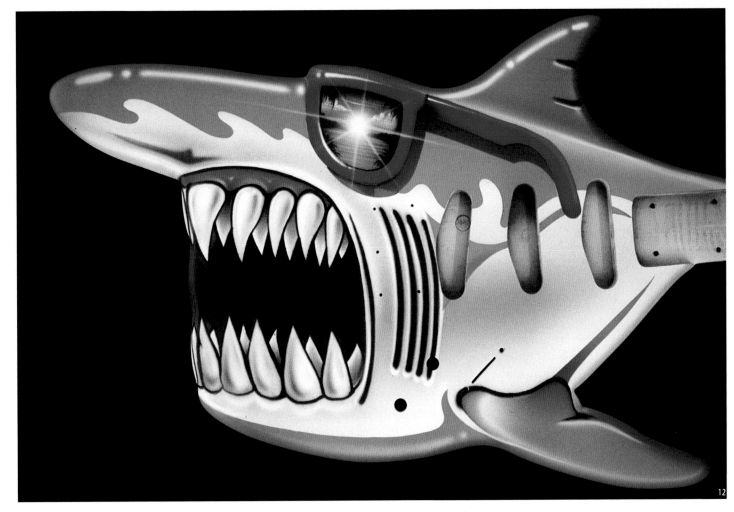

TERRY HILL

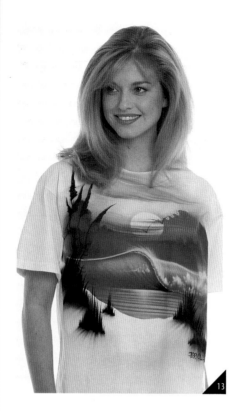

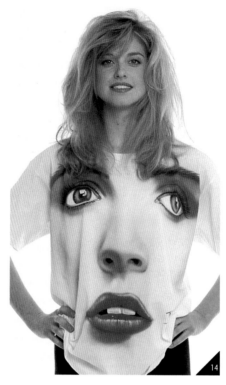

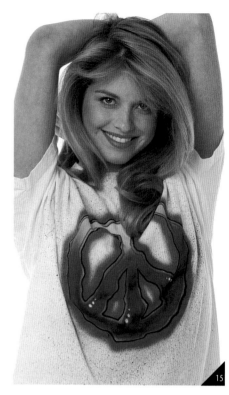

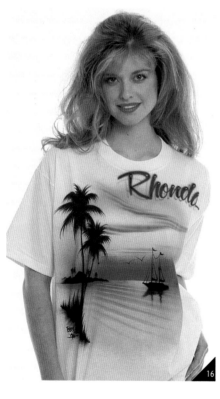

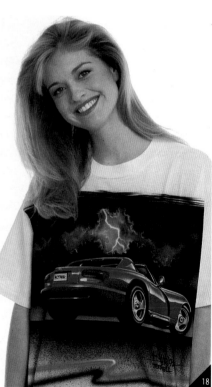

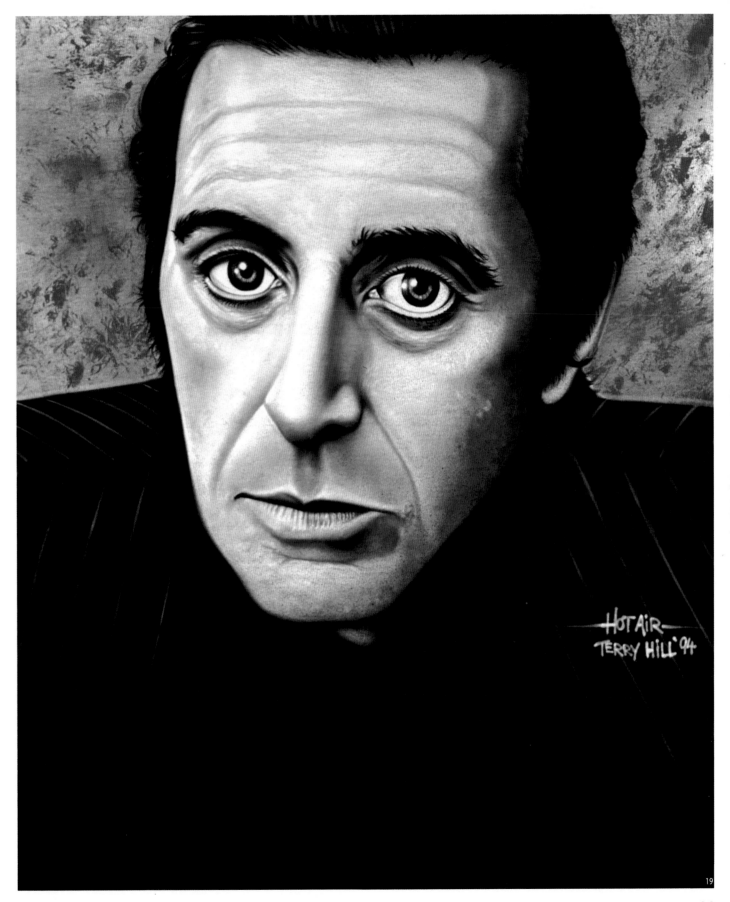

MICHAEL ASTRACHAN

Michael Astrachan has been airbrushing T-shirts since 1984, and currently owns Island Airbrush *in Meriden, Connecticut. He holds a degree in fine arts from Yukon University and has studied oil painting with the artist John Murray. Astrachan's style employs techniques of the old masters, and of the French neoclassical painter Jacques-Louis David. In this technique, Astrachan applies the oil painting value system to creating realistic air brush portraits.*

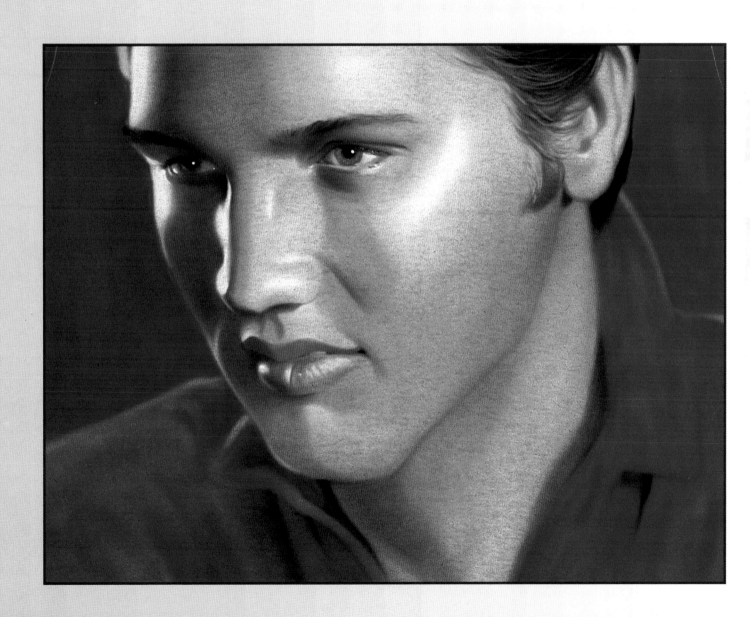

PAINTING REALISTIC PORTRAITS

This technique is the result of two years intensive study of oil painting. Several years ago, I was airbrushing T-shirts at Connecticut malls. When portraits on T-shirts became one of my most popular items, I decided to take a break from airbrushing and to study portrait painting in oils.

In these steps, I demonstrate my adaptation of oil-painting techniques by painting a color airbrush portrait using the value system. The portrait I reproduce here is illuminated by form lighting; approximately 75 percent of the face is in light. Various degrees of white, tinting black, golden yellow, red, and dark brown were mixed to create the palette of 7 flesh tone values. I offer no tricks or short cuts, but instead stress the importance of knowledge, which elevates airbrushed portraits beyond mere copying of photographs; for great portraits are windows of the soul.

TOOLS:

PAINT:
Createx Transparent
Airbrush Colors
AIRBRUSH:
Iwata HP-BC Airbrush
AIRBRUSH COMPRESSOR:
Rol-air 3/4 Horsepower
Compressor
VENTILATION:
Respro Ventilation Mask
HEAT PRESS:
Hix HT400 Heat Press

STEP 1. State the accents using black paint; since nothing else will be as dark, painting the accents first creates a good reference point. They will have to be restated later because overspray will lighten them. Since values are judged by comparison to other values, pay close attention to how value choices compare to the picture you are copying.

STEP 2. Paint the big shadow on the head. Pick out details in this shadow with a darker shadow value. Unlike the accents, shadows are almost never completely black because light scatters into them from surrounding objects.

STEP 3. Now add the light. Look at the reference picture again and match the light value. Here, the lightest light value is on the right section of forehead, the place where light strikes first.

STEP 4. Paint in the middle light value (middle section of face).

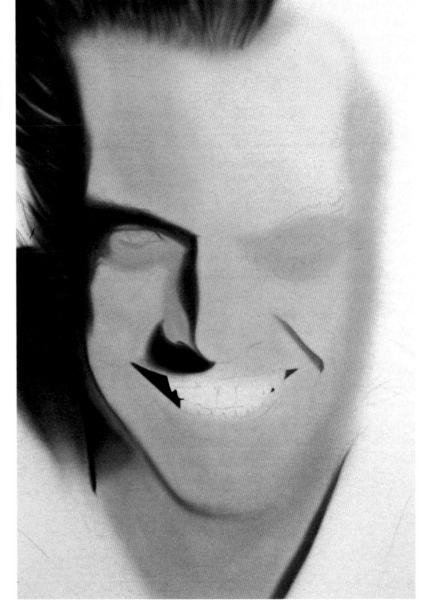

STEP 5. Paint in the low light value on the remaining face and neck sections, painting in bands from top to bottom. The highlights will be added later.

STEP 6. Next, paint in the planes of the head. Alone, the bands of light appear flat; the planes create depth and make the portrait recede in the picture space. The major planes of the head can be divided into a cube: the face and forehead make up the front plane; the side planes contain the cheeks, temples, and ears; the top, scalp and hair; the bottom, the throat and the underside of the chin. Begin with the side planes, which cut through two bands of light values. Drop one value as the plane turns away from the light.

STEP 7. Since the eye sockets are recessed in the skull, paint them one value darker than the rest of the area. Paint the left eye socket with the low light value, and the right eye socket using the middle light value.

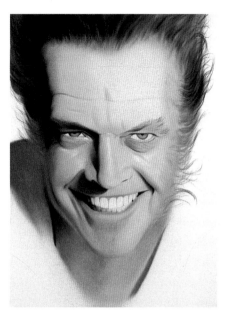

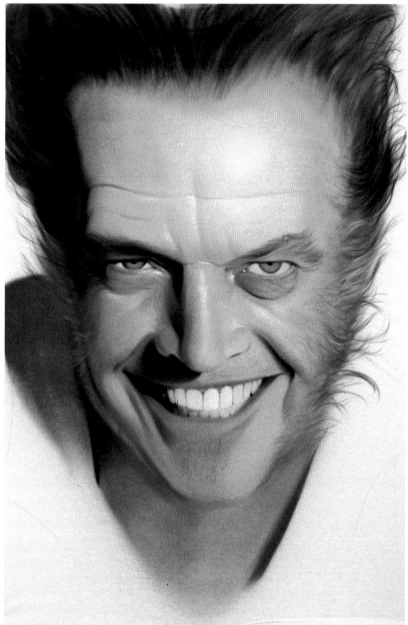

STEP 8. Next, blend the areas between shadows and flesh tones by painting them with a half tone value. Half tones are part of the light in portrait art, and should always be painted lighter than the shadow.

STEP 9. Paint the minor planes, keeping in mind that planes facing away from the light are slightly darker than planes receiving the light.

STEP 10. Add the highlights, using the highlight value and pure white. White is reserved for the brightest highlights at the center of a form (tip of the nose) or at a plane change (the sharp angle between the front of the nose and the side.) Be attentive to the topography of the face—soften the edges of the head to make it look three-dimensional, rather than cut-out and pasted onto the T-shirt. Use hard edges to draw attention to bony areas.

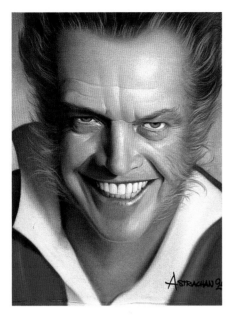

STEP 11. The final step is adding the local color—eyes, cheeks, lips, etc. The nose and cheek zone tends to be reddish, so the painter must spray in red or iron oxide. Similarly, the gray zone—from the bottom of the nose to the bottom of the chin—calls for subtle gray, which dulls the color. Edges sometimes require gray, too. If the reference is an indoor photograph, its shadows may be warm or gray. Make the portrait shadows match by adding red or gray to them. If you are working from an outdoor photograph shadows tend to be cool, requiring an added purple or blue tint. Because of the overspray, you may need to restate the highlights now.

STEP 12. In the finished painting, all of the points discussed are clearly evident: light flows over the head, the side planes recede in space, the flesh describes form, and the edges create atmosphere.

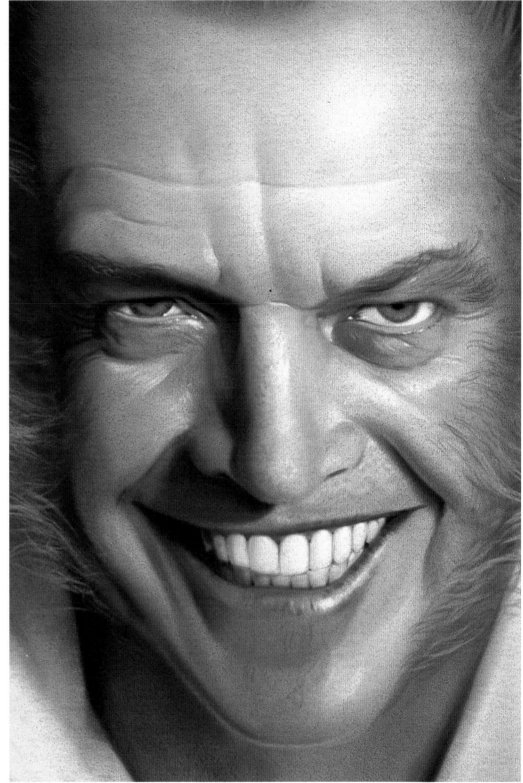

MICHAEL ASTRACHAN

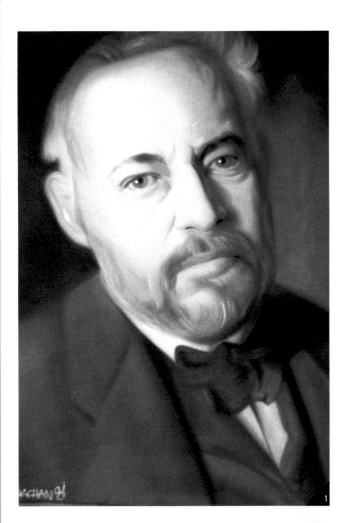

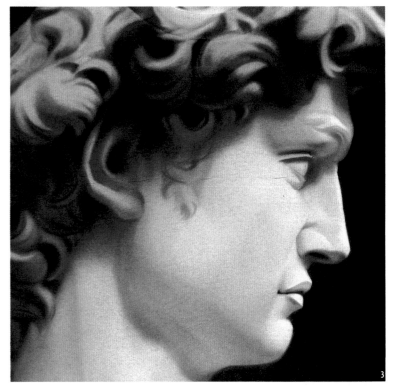

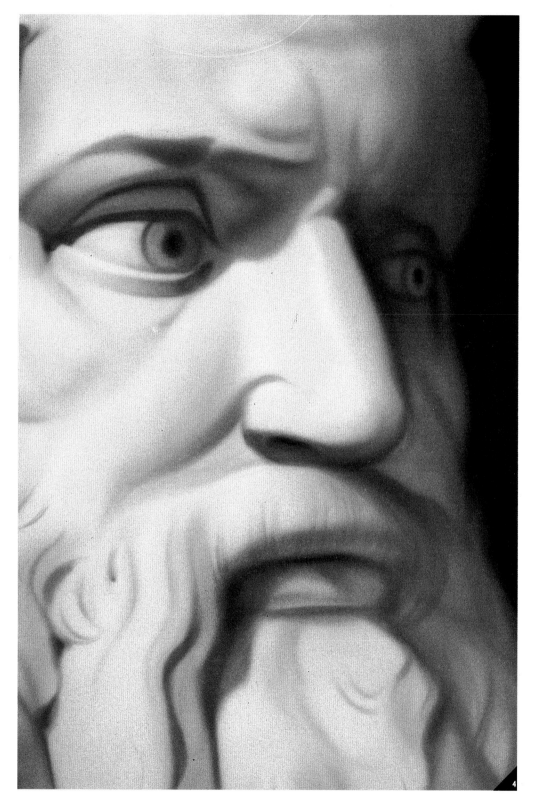

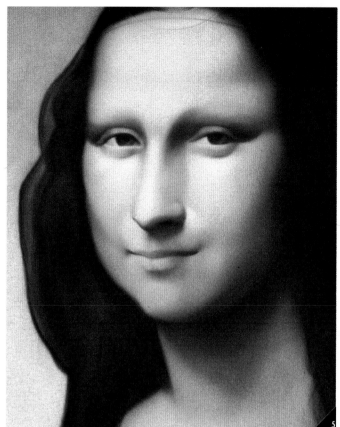

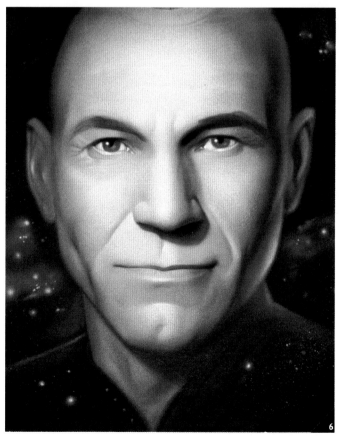

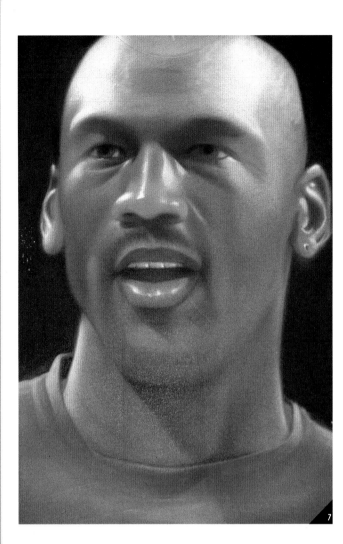

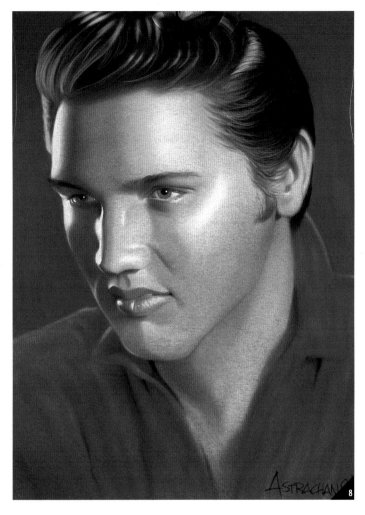

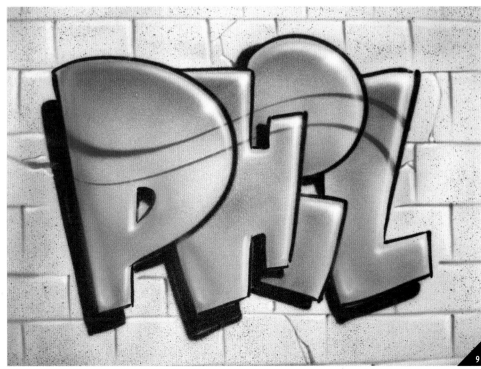

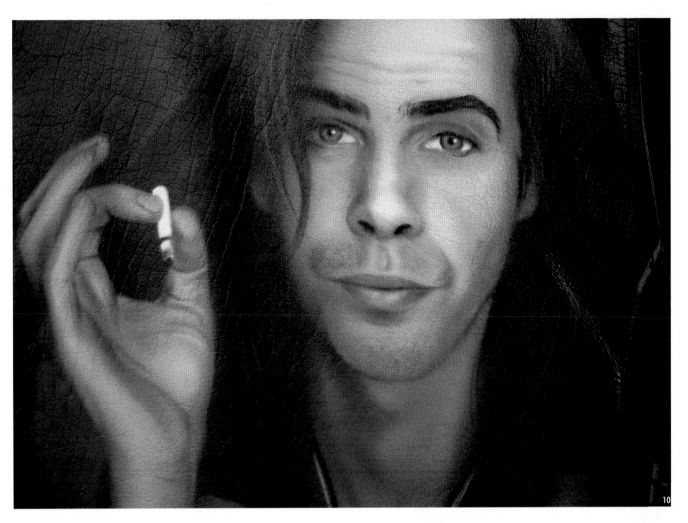

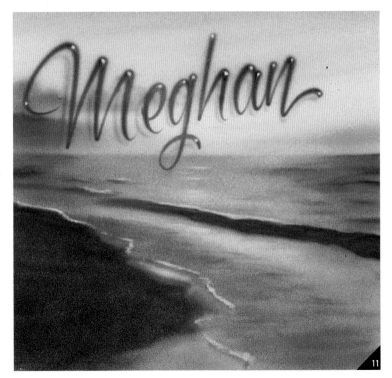

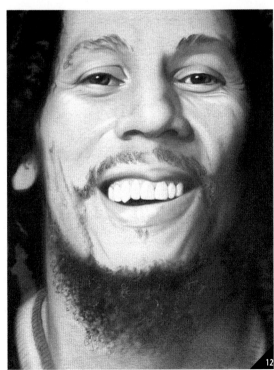

MICHAEL ASTRACHAN

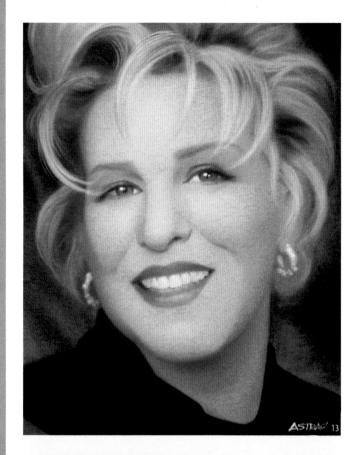

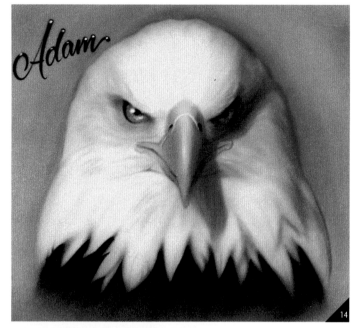

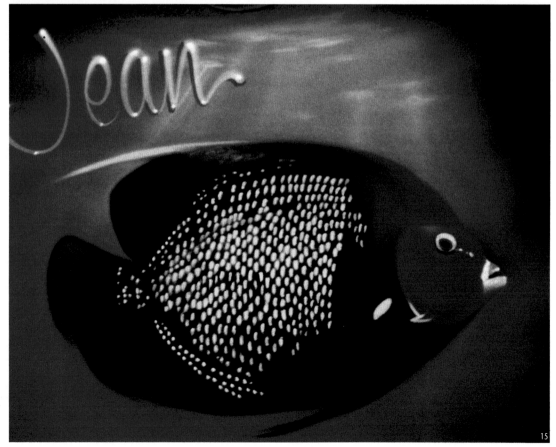

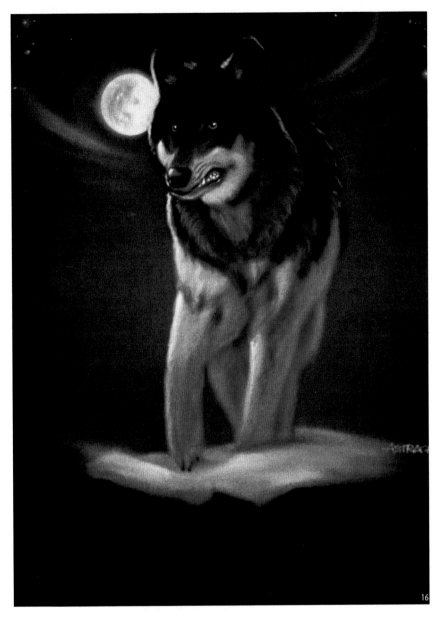

16

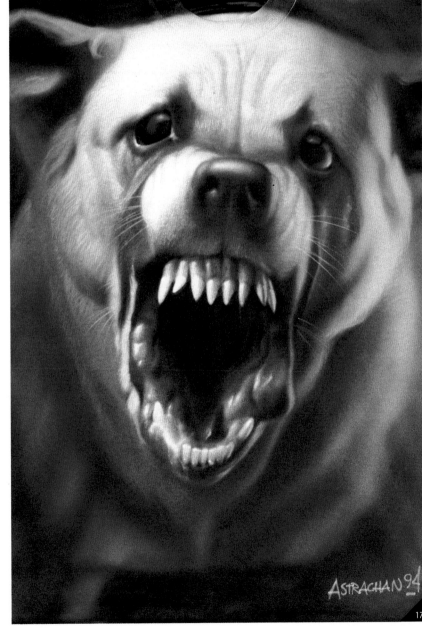

ASTRACHAN 94

17

MICHAEL ASTRACHAN

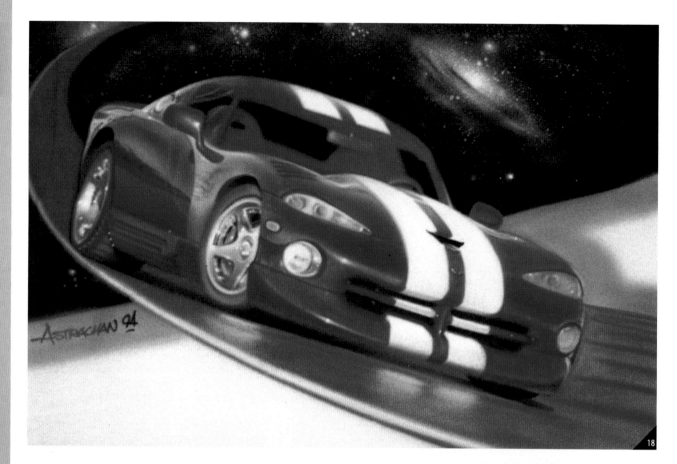

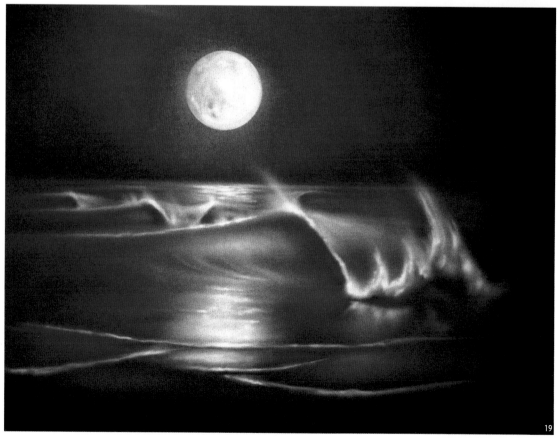

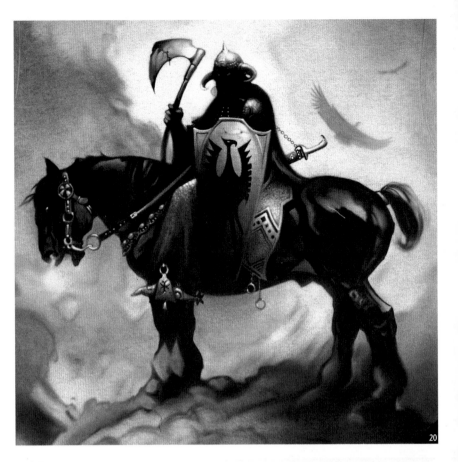

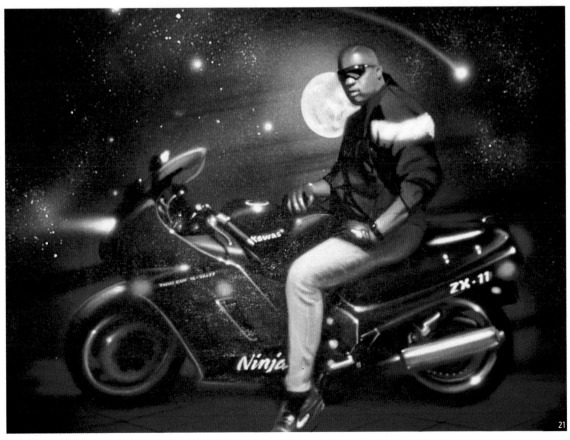

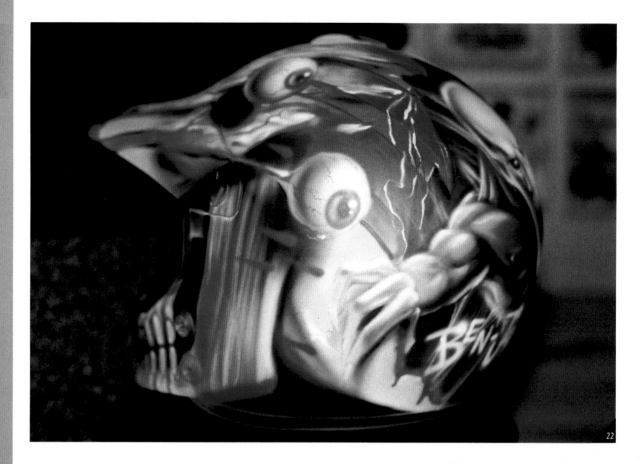

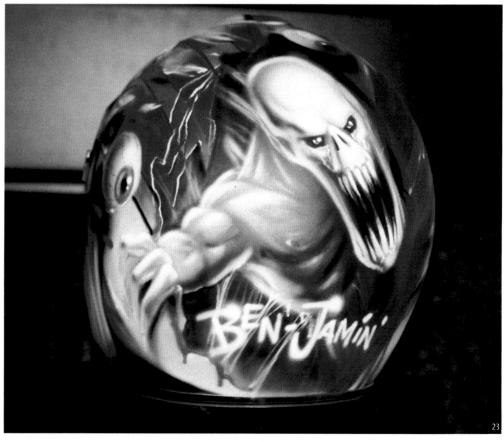

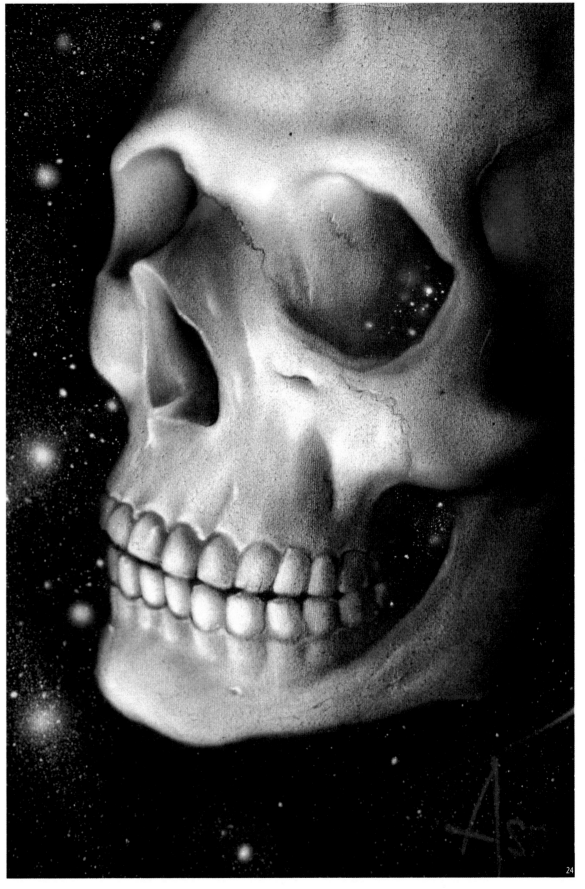

STEVE

DRISC

STEVE DRISCOLL

Steve Driscoll began airbrushing in Las Vegas, Nevada. He moved on to Chicago, where he airbrushed for two years, and quickly rose in the ranks as one of the best T-shirt portrait artists in the country. Driscoll specializes in super-realistic portrait painting, and has just finished two new airbrush instructional videos. His approach is first to try to be the best, then the fastest. "If you can get the first one, the second one is bound to follow," says Driscoll.

He currently lives with his wife and child in Minneapolis, where he operates Air 2B Difrent with his partner, Kent Lind.

SPECIAL EFFECTS

Painting realistic faces is one of the most difficult airbrush skills to master. The same face can change in appearance, depending on the angle it is viewed from and the location of the viewer. When approaching a portrait, the task is to make a three-dimensional image on a flat surface. To accomplish this, you need to keep in mind dark and light values as well as the textures and hues of the skin.

This technique uses semi-transparent colors applied slowly and systematically to build realistic skin tones. In choosing a reference photo, clarity is more important than size. I would prefer a clear 2x2 inch photo to an out-of-focus 8x10. Choose a pose that compliments your subject's personality and include as much detail as possible in your original sketch. This eliminates guesswork and gives you a good map to follow when you start painting. I prefer white T-shirts, so the color of the shirt doesn't interfere with the painting.

TOOLS:

PAINT:
Createx Transparent
Aribrush Colors
AIRBRUSH:
Thayer and Chandler's Vega 2000
AIRBRUSH COMPRESSOR:
Silentaire one-horsepower compressor
VENTILATION:
Respro Ventilation Mask
HEAT PRESS:
Stahl's

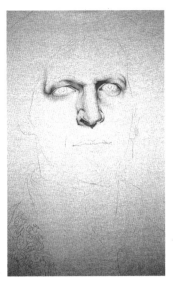

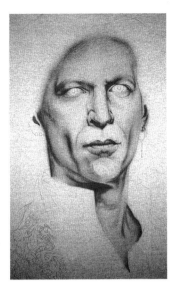

STEP 1. Draw the image onto the shirt using a soft orange pencil (a dark pencil will show through the finished painting.)

STEP 2. Match the overall skin tone in the reference with a middle tone and use it to paint the entire portrait in a monotone value study. Pretend that this is the only color you have.

STEP 3. Continue to build the light and dark areas, paying close attention to detail and overall value.

STEP 4. The color used here is a mixture of one ounce Createx light brown, six drops golden-yellow, three drops flamingo pink, six drops tinting white, and one half-ounce of transparent airbrush extender. The extender increases the paint's transparency so flesh tones can be built gradually and with great vibrancy.

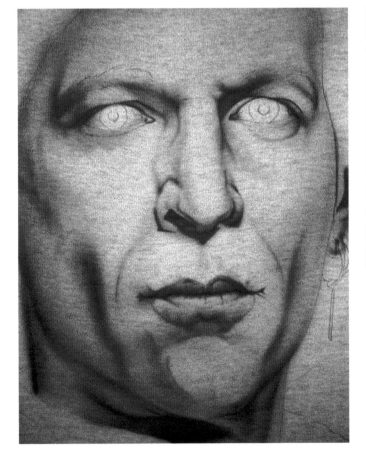

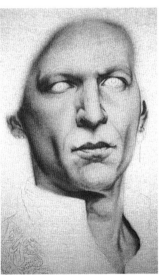

STEP 5. Lightly mist the portrait with a thin yellow wash, keeping the airbrush six to eight inches from the surface. Add one 1/2 ounce of yellow to the base color to bring it closer to the final flesh tone.

STEP 6. Add a pink hue by spraying a mixture of one half-ounce transparent extender, one half-ounce flamingo pink, and six drops of light brown, over the first two colors. Pink can be very dominant, so use it sparingly, concentrating on the lips, nose, cheeks, tear ducts, and eyelids.

STEP 7. Next, add the darker shadows, using a mixture of one half-ounce light brown, one half-ounce dark brown, and ten drops of violet. Violet ties together the brown tones in the face and warms the shadows. To keep the image from becoming too dark, add the shadows very slowly.

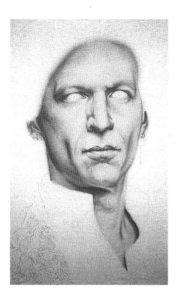

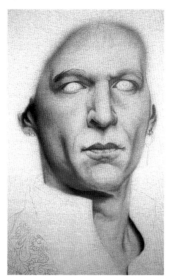

STEP 8. Mix together one half-ounce tinting white, six drops golden-yellow, and six drops light brown, to begin painting the highlights. Do not add any extender, since it dilutes the pigment too much for it to cover. Highlighting starts to develop the image into a three-dimensional shape. Avoid pure white highlights, they don't blend into the painting and instead appear laid on top of the shirt.

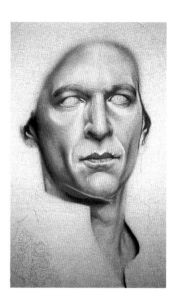

STEP 9. Spray the dark areas of the face, including the sides of the face and neck, using a mixture of 50 percent light brown, 50 percent extender. Keep the airbrush six to eight inches from the shirt surface for this step.

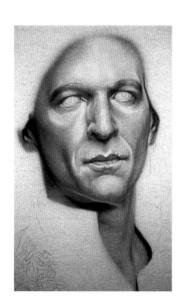

STEP 10. To paint the hair, picture it as a solid sculpture with overall light and dark patterns. Painting a single strand of hair at a time yields a flat, lifeless, monotone result. Pay close attention to the direction of the hair, also.

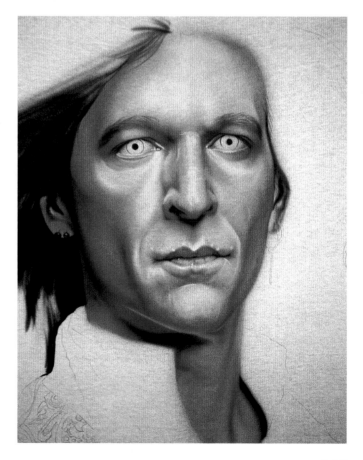

STEP 11. Once the general hair shape and direction are finished, add some fine lines outside the silhouette. Leave the lighter areas open for highlights and darken the shadows. The right earring was also left unpainted.

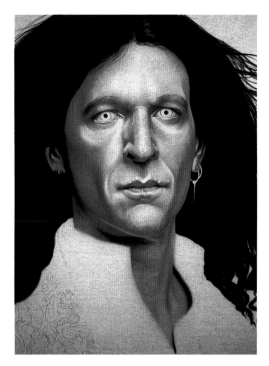

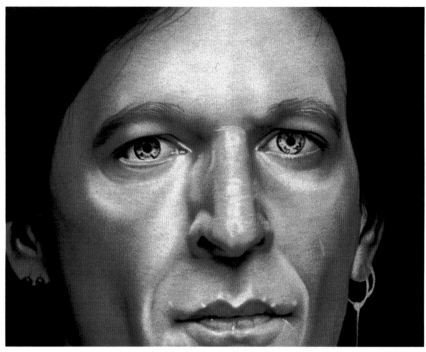

STEP 12. The pupils are painted with a mixture of one ounce dark brown one half-ounce ounce violet, and six drops of black. The very dark hair in Step 11 is also painted with this color.

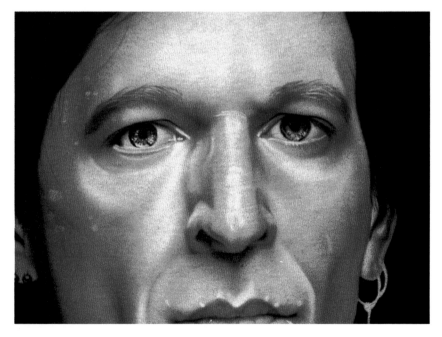

STEP 13. Lightly mist blue-gray over the iris. Using the highlight color from Step 8, add bright flecks to the eye.

STEP 14. Begin the paisley vest by carefully laying in the base design using black.

STEP 16. Texture the lace shirt by using two paper doilies as templates. By spraying through lace or similar patterns, you can quickly and easily simulate intricate textures.

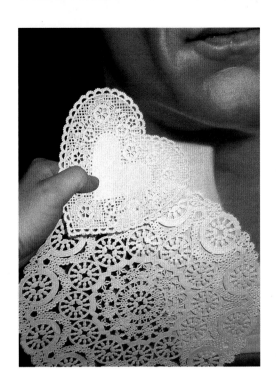

STEP 15. Spray transparent red over the top of the design, covering the whole surface.

STEP 18. Finish adding the white highlights to the face. The portrait is complete with hair, clothing, skin tones, and textures.

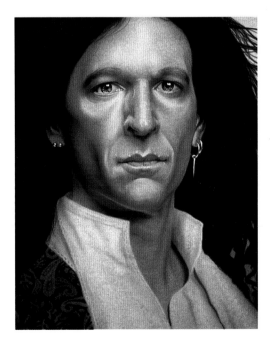

STEP 17. Add beige to create the folds and dark areas of the shirt. Then, place the doily on top of the area and re-spray beige over most of the shirt. Place the doily over the shirt a final time, and use white to create highlights.

TECHNIQUE FOR A SUPERIOR T-SHIRT

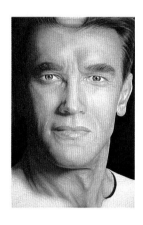

Choose a quality T-shirt to paint on. Keep in mind the shirt should be smooth and free of loose fibers. Stretch the shirt over a shirt board, tight but not so tight that it distorts the artwork when taken off the board. Then tape a border around the area to be airbrushed with good masking tape so the painting has a clean edge.

After a clean edge has been formed, use a soft orange pencil to draw the figure onto the shirt. Orange is best since, unlike lead or black pencil, orange lines will disappear under the paint. This step was done freehand only because I had the time. But when time is short and the minute hand looms like a guillotine directly overhead, I frequently use an opaque projector.

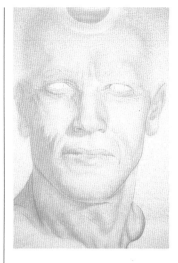

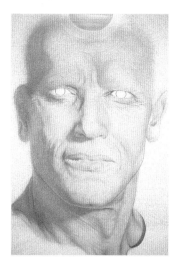

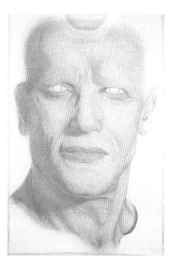

STEP 1. Begin this step by mixing (in a 3 oz. jar) 1 oz. of Createx transparent extender, 1 oz. light brown, 1 drop fluorescent magenta, and 3 drops golden yellow. The transparent extender allows the paint to remain translucent so you can build the flesh tones gradually and get a great glow to the skin.

Start painting by thinking that this is the only color you have and paint lightly to keep the portrait clean and crisp. Do not sketch with the airbrush or you will end up with an image that is muddy and unacceptable.

STEP 2. Continue to build detail and shape to the face. Pay very close attention to your reference photo and look at it often. After the details are in place and the face has shape and depth, mist a very light spray of color over the entire area. Don't worry about keeping the whites of the eyes too white since they reflect colors around them and are round...so there will usually be a shadow at the top.

STEP 3. With a mixture of 1 oz. Createx transparent extender, 1/2 oz. light brown, and 1/2 oz. dark brown, start to bring the shadows and dark areas of the face out. Be careful to blend the dark and light areas smoothly so the transition from dark to light is natural. This will give the face and head a three dimensional quality.

STEP 4. This step will begin to bring a natural glow to the portrait. Start by mixing 1/2 oz. transparent extender, 1/2 oz. fluorescent magenta, 3 drops tinting white, and 6 drops light brown. Lightly spray the lips and inside corner and bottom lid of the eye. Pink is also found under and around the eyes, on the nose, cheeks, and shaded side of the face. Pink is used instead of red because red is very overpowering and can actually make your undercolors darker. But be careful, pink can be just as bad if overused.

Next mix 1/2 oz. transparent extender with 1/2 oz. golden yellow and mist a light spray over the entire flesh area.

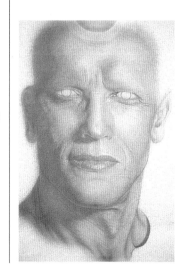

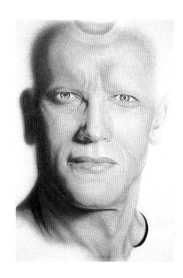

STEP 5. Now mix 1/2 oz. transparent extender, 1/2 oz. tinting white, 3 drops light brown, and 3 drops golden yellow. This will be used to highlight the skin where the light hits and reflects. I use this color instead of white because white is too harsh in contrast to the flesh tones. Some white will be used later for some final highlights. Orange is also sprayed onto the dark side of the face and nose.

STEP 6. Now use 1/2 oz. transparent extender, 1/2 oz. dark brown, 1/4 oz. purple, and 3 drops tinting black to paint the darkest shadows and details of the face.

STEP 7. Using the same mixture as in step 7, start painting the detail of the pupil and iris of the eye.

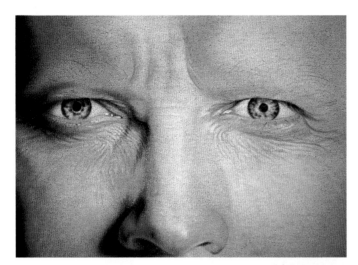

STEP 8. To finish the eye color, use dark brown as the base color with flecks of light brown and towards the center use the highlight color from step 5.

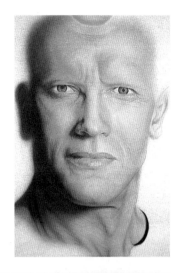

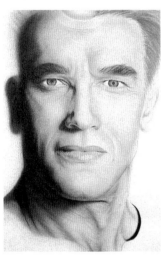

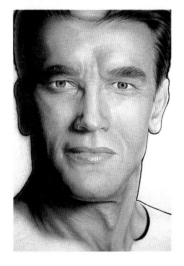

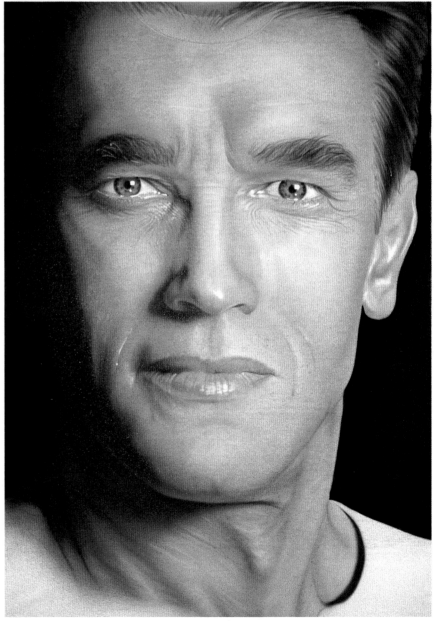

STEP 9. To begin the hair color and eyebrows, use 1/2 oz. dark brown and 1/2 oz. beige. Keep in mind that there are light and dark areas to both the hair and eyebrows as well as direction and style of the hair. Be sure to keep a close watch on the hairline so it doesn't get too high or low.

STEP 10. With the mixture from step 7, paint the dark areas of the hair, carefully blending into the light areas to create the softness and shine to the hair.

STEP 11. Next, the opaque black background and beige shirt are added. The final step involves inserting white highlights on the tip of the nose, on the bottom of the eyes, on the ears, and, of course, to develop the twinkle in the eyes.

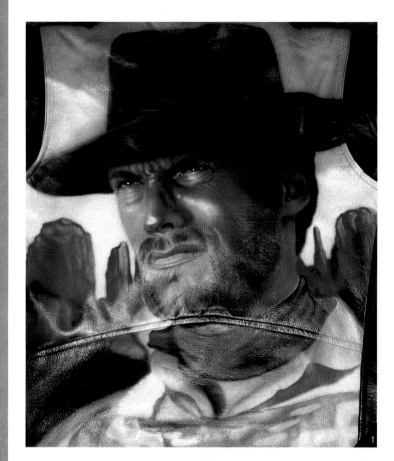

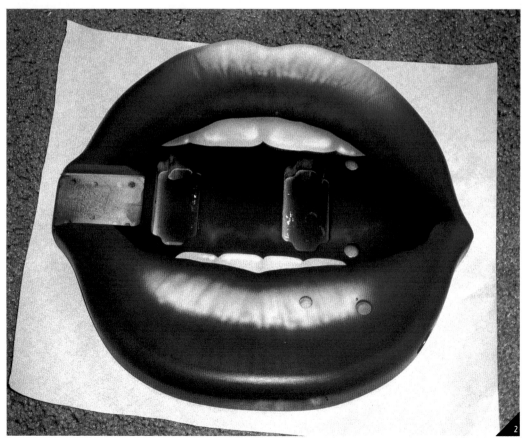

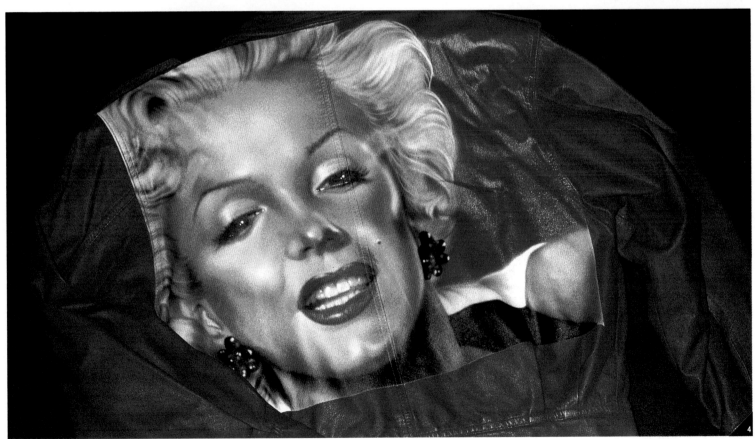

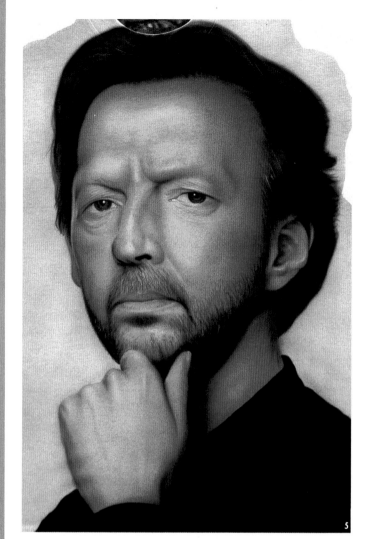

5. Clapton
6. Gilbert Godfried
7. Bob Marley

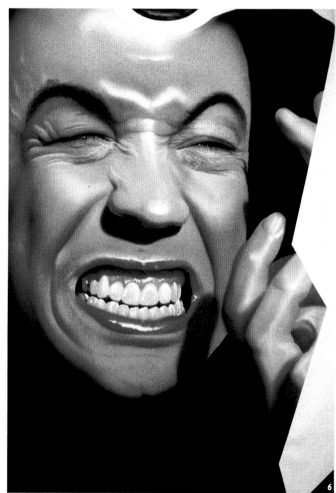

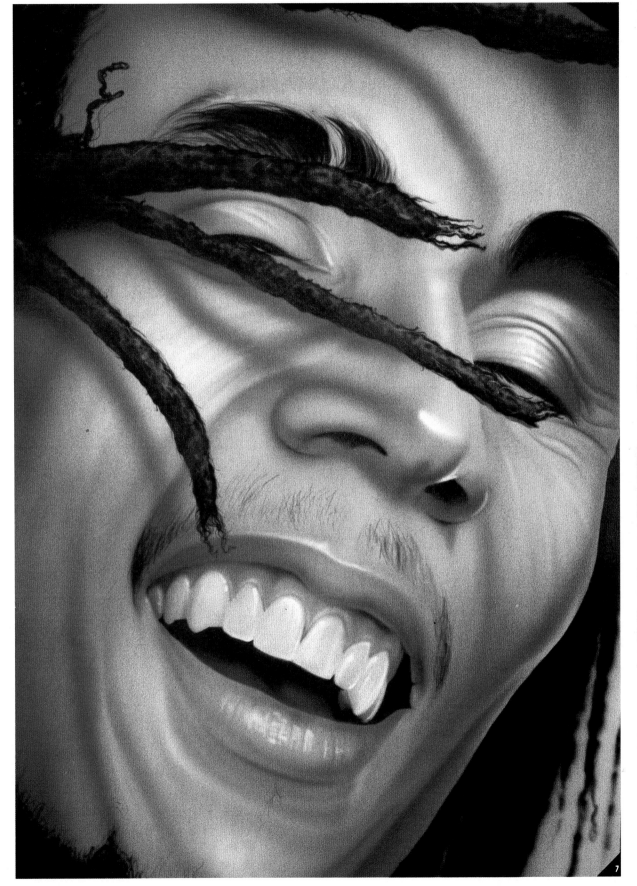

STEVE DRISCOLL

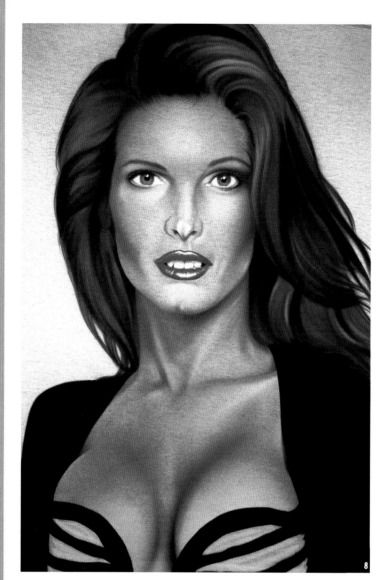

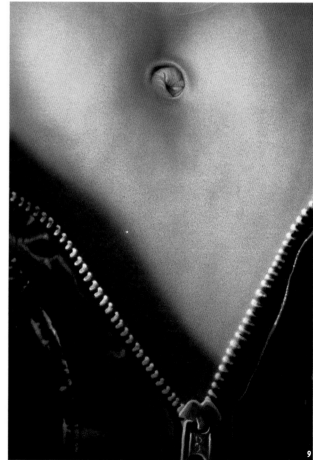

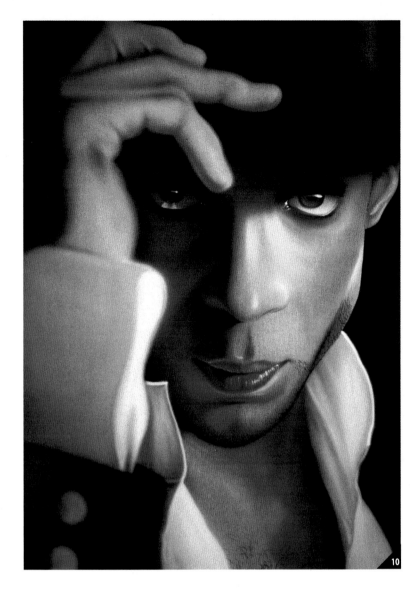

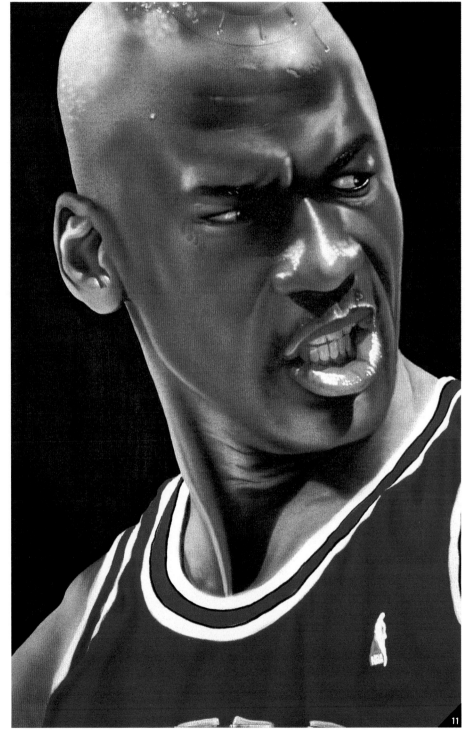

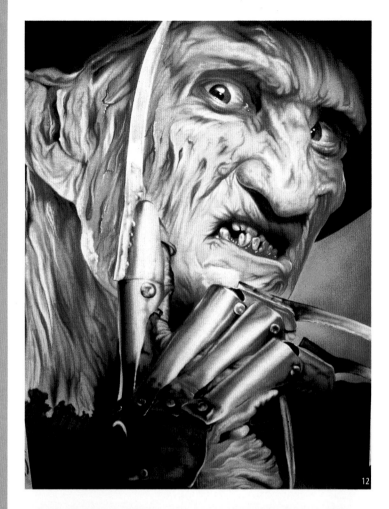

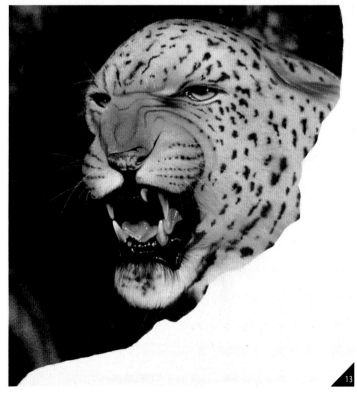

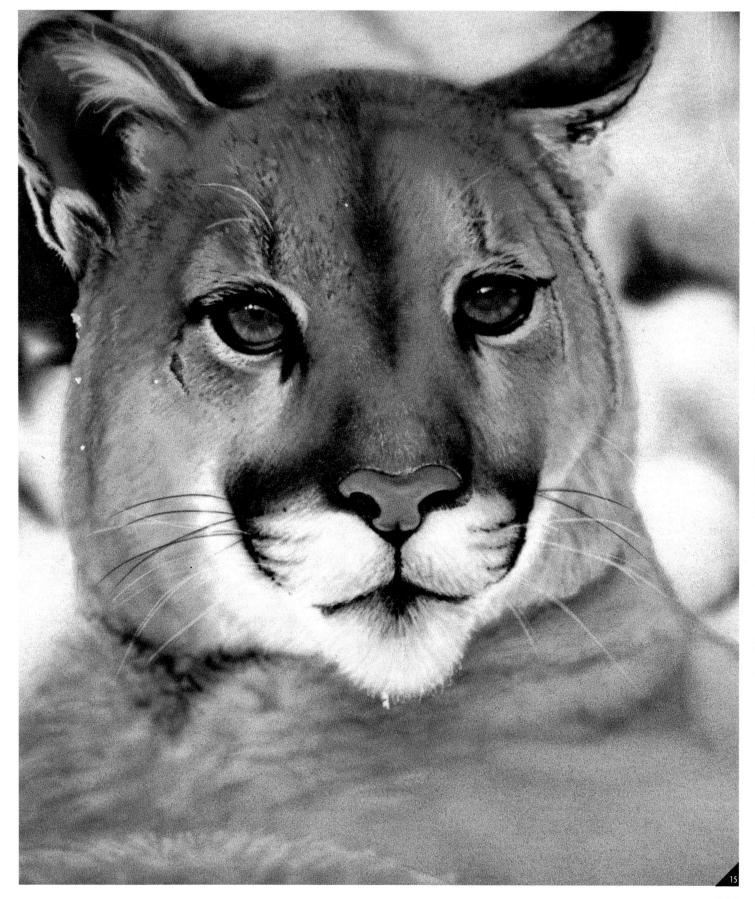

STEVE DRISCOLL

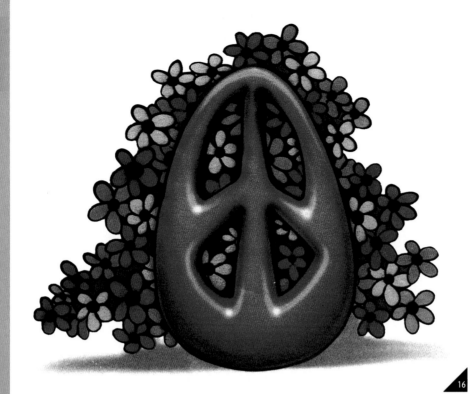

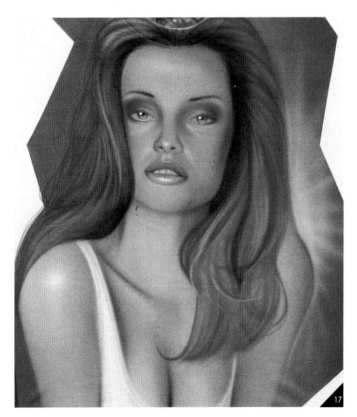

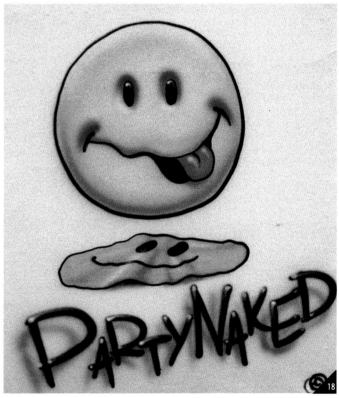

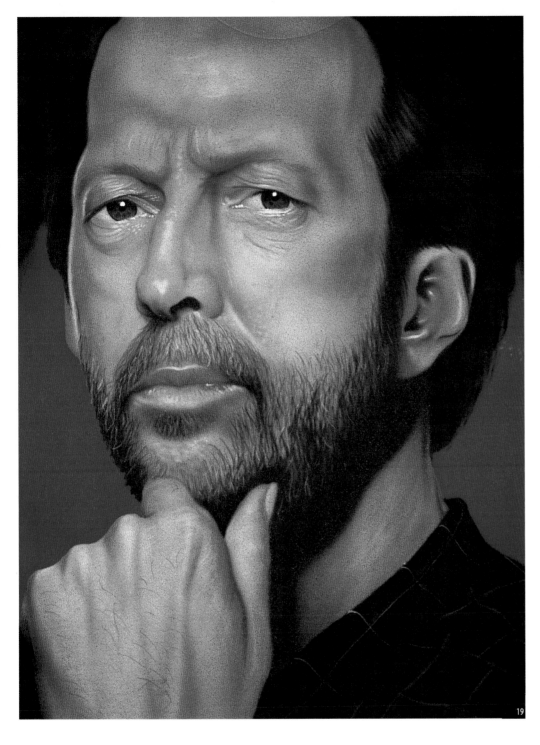

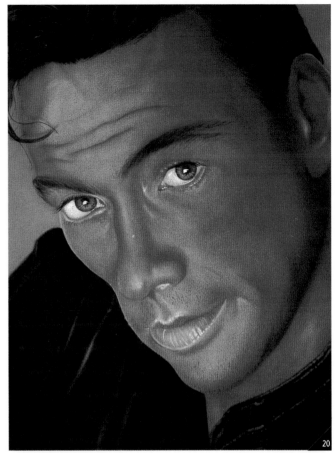

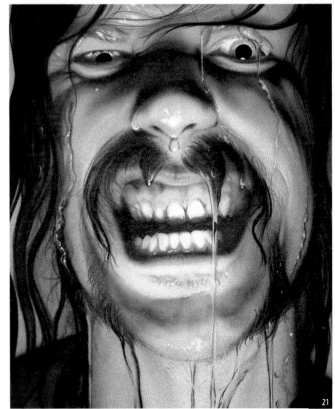

CHAMPA

RICH

RICH CHAMPAGNE

A New Orleans native, Rich Champagne has been air-brushing T-shirts commercially for seven years. His specialty is realisticportraiture, but he paints everything from cars to castles. Champagne has two airbrush instruction videos on the market, and plans to open a studio with an illustration focus in the near future.

Rich Champagne's technique for airbrushing portraits combines the tricks, techniques, and mediums of several different portrait styles. Although he believes each individual artist should adapt his advice to suit their particular style, his methods of creating sharp contrasts and smoothly blended photo realism are widely copied.

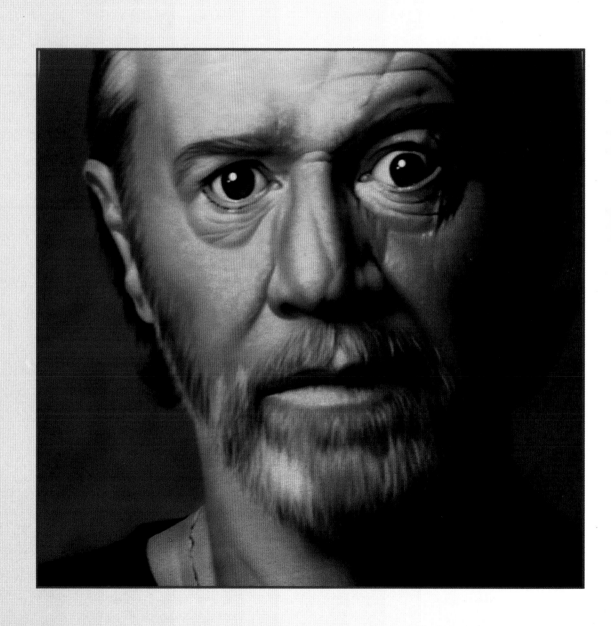

PORTRAIT PHOTOREALISM

Today's T-shirt airbrushers are pushing the limits of their art. Many are going beyond simple name designs and beach scenes. The portraits, cars, and animal portraits that constitute the majority of custom work are rising to higher levels of photorealism.

In portrait painting, I use the same basic skills used for everyday name designs; soft shading, bright highlights, and dark shadows. The only difference is the amount of time and the level of concentration needed to finish the piece. I begin a portrait with a base monotone value painting, breaking the colors of an image down almost like a black and white painting. Layers of color are then sprayed on the monotone picture to blend with the underpainting and bring the portrait to life.

A desire to test new techniques, and a growing need to create more traditional forms of artwork, has pushed me more into portrait painting, and to trying to live up to the label: airbrush artist.

TOOLS:

PAINT:
Dr. Martin's Ready-Tex
AIRBRUSH:
Thayer and Chandler's Vega 2000
AIRBRUSH COMPRESSOR:
Craftsman ¾ horsepower compressor
VENTILATION:
Custom made air filtration system
HEAT PRESS:
Hix Heat Press

STEP 1. Prepare the shirt and mask-off the edges. Lightly sketch the portrait.

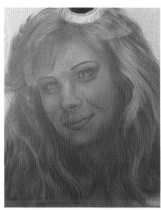

STEP 2. Use the mixed flesh tone across the entire subject; spray it onto the face and the hair as a base coat. Use the same color to add detail around the eyes and mouth, and to rough out the shadows and direction of the hair flow. Do not worry about the background at this point or keeping the whites of the eyes clean. This portrait has a dark background which will cover any stray color, and whites of the eyes are rarely ever white. The overspray creates the necessary shading.

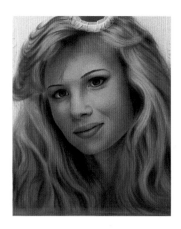

STEP 3. Build up the depths in the painting using light brown. Stay tight on the sharp lines and edges, and lightly build up the shadows in the hair, and most of the detail in the face. When painting a portrait, remember that the shading should be a smooth transition from light to dark. Simply spraying dark brown lightly will not give you this effect, in fact, your portrait will turn out grainy.

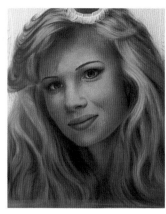

STEP 4. Use dark brown to build darker shadows, and create more depth and detail. Note the shading on the forehead. The subject in the reference photo has very light, thin bangs which stand out before a dark background. Since this hair will later be painted with opaque highlight colors, the shadow may be painted as one area.

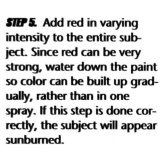

STEP 5. Add red in varying intensity to the entire subject. Since red can be very strong, water down the paint so color can be built up gradually, rather than in one spray. If this step is done correctly, the subject will appear sunburned.

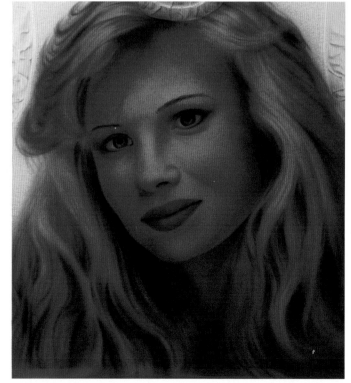

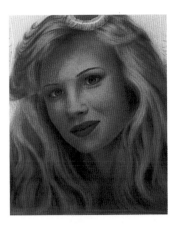

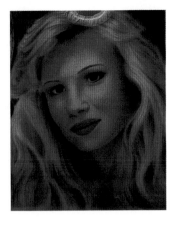

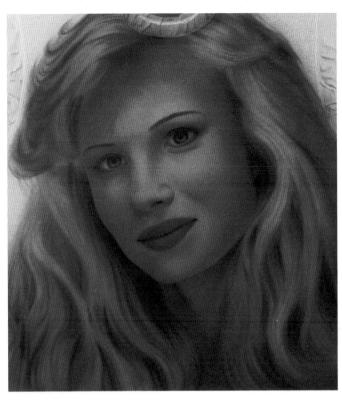

STEP 6. Using the technique described above, apply yellow. Yellow tends to be translucent rather than transparent. Yellow tends to be in flesh tones more than one actually realizes. Don't be afraid to keep building up the color.

STEP 7. Add another coat of red to restore any coloring overpowered by the yellow.

STEP 8. Apply orange to the hair, extending it from the darker areas to provide a smooth transition from dark to light.

STEP 9. Use blue to darken some of the shadows, and to add a cooler, more natural feeling to the painting.

STEP 10. Fill in the mottled background with black. Allow a slight amount of overspray to fall on the edges of the hair—giving it a more realistic effect. Use black to shade the subject's eyes, the dark shadow on the edge of the face, and the shadows in the hair and on the forehead.

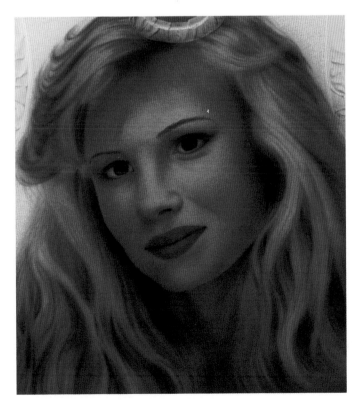

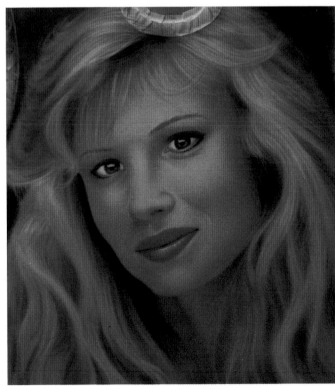

STEP 11. Use mixed flesh tone to add highlights to the entire portrait, including the edges of the face and the detail in the hair. Lighten the whites of the eyes and lay in the thin strands of the bangs.

STEP 12. Give the hair a little more detail adding dark brown lines and push back some of the highlights by shading.

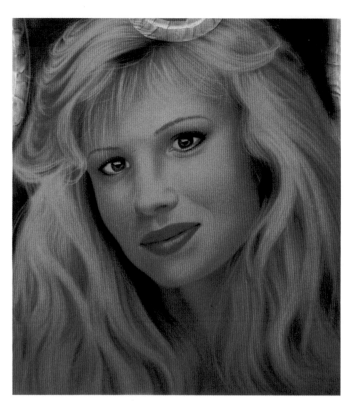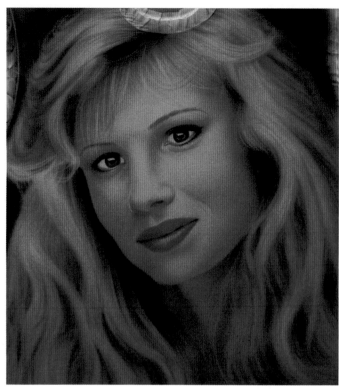

STEP 13. Lightly layer the entire painting with varying yellow tones to gain back some of the lost color in the hair and to add a bit of color to the highlights.

STEP 14. Spray orange on the transitions out of the shadows, and lightly over the face to add more color to the highlights.

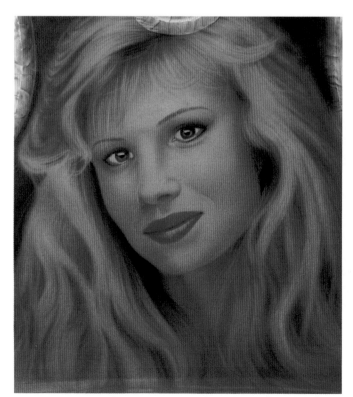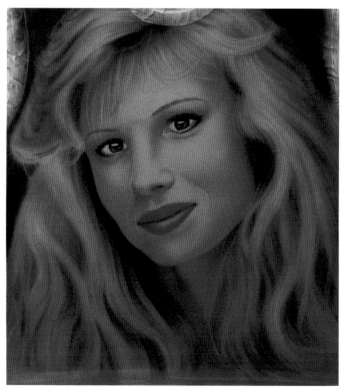

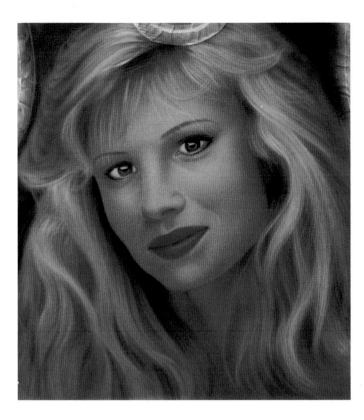

STEP 15. Add bright highlights with thinned opaque white, slightly lightening the whites of the eyes, and highlights in the hair. Opaque paints are characteristically thick and tend not to flow very well. Thinning the paint helps in spraying the long thin lines and in creating the light shading.

STEP 17. The completed shirt after it has been signed, clearcoated, and pressed.

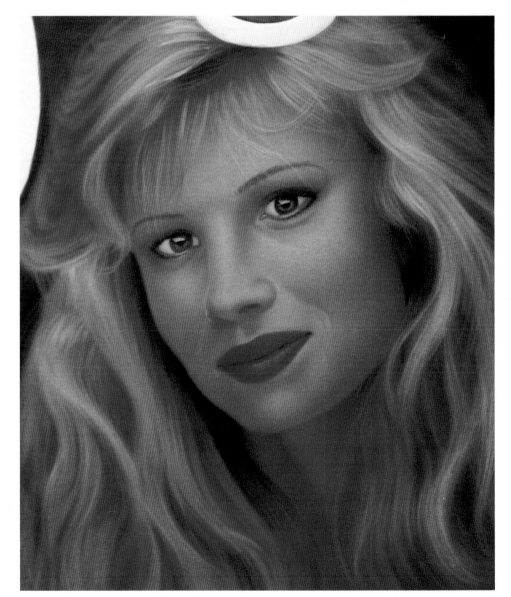

STEP 16. A hint of red sprayed over the lips tones down the highlights and blends them into the whole.

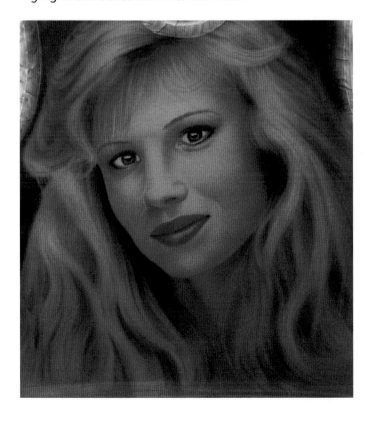

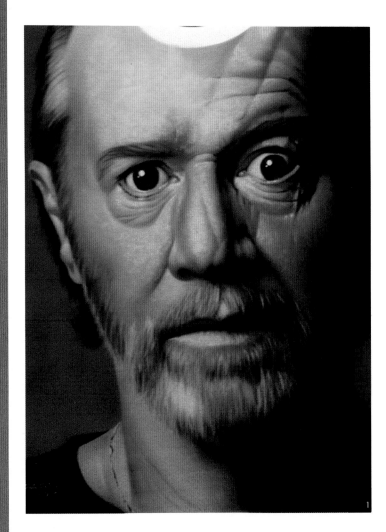

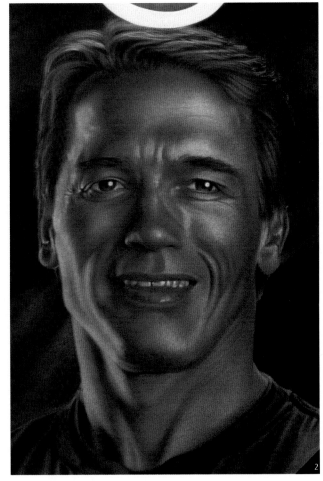

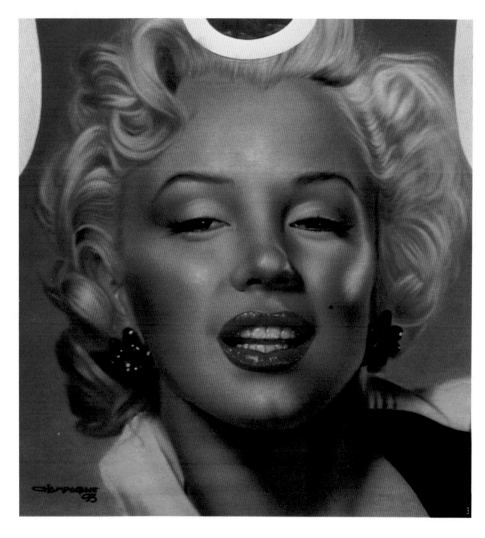

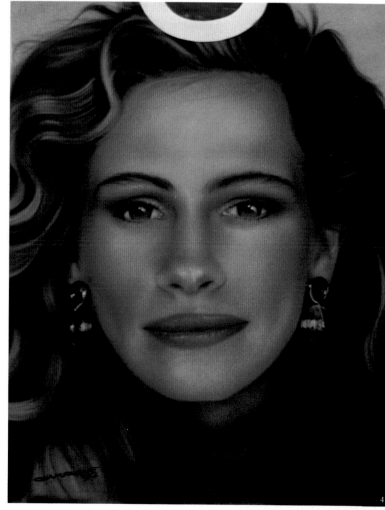

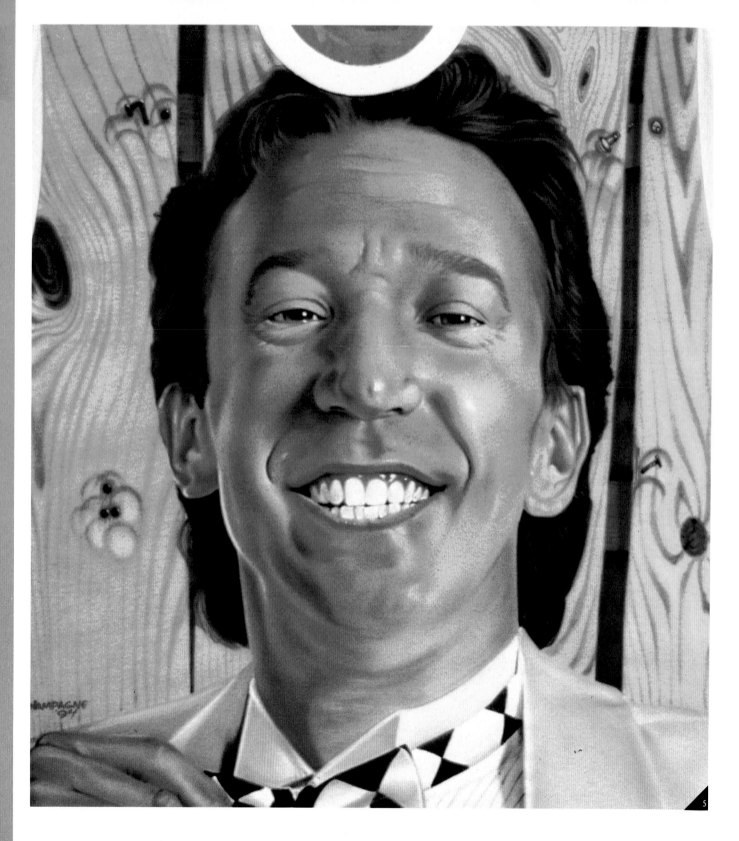

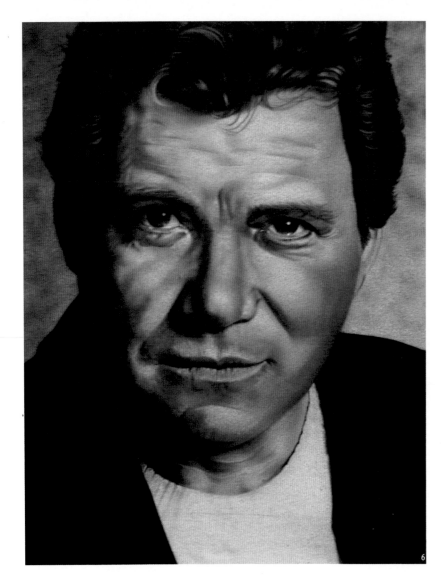

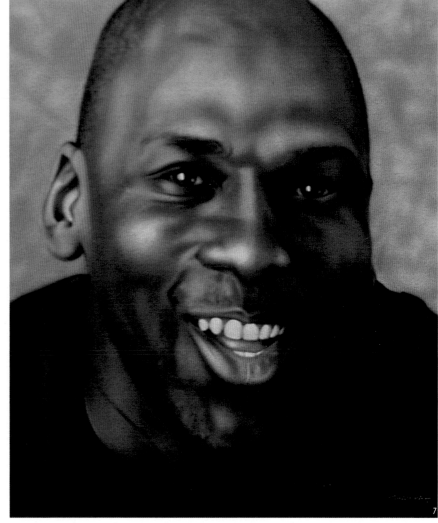

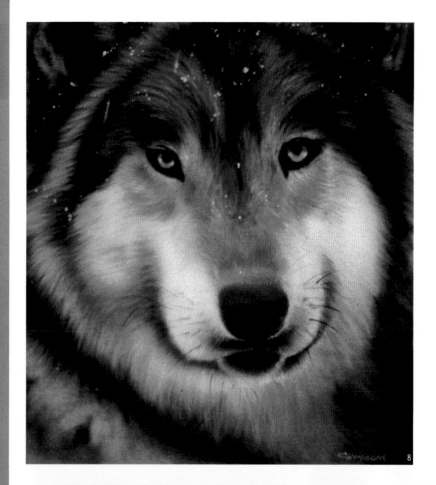

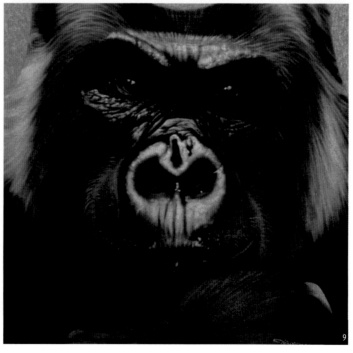

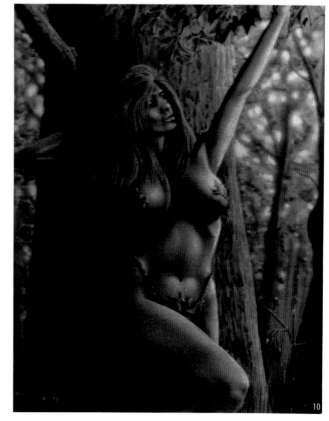

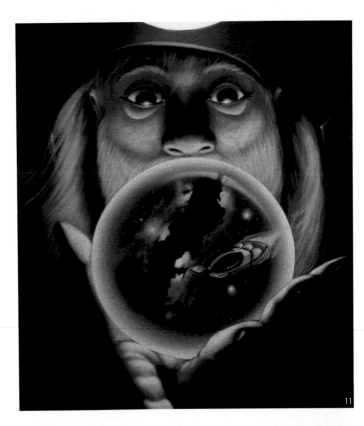

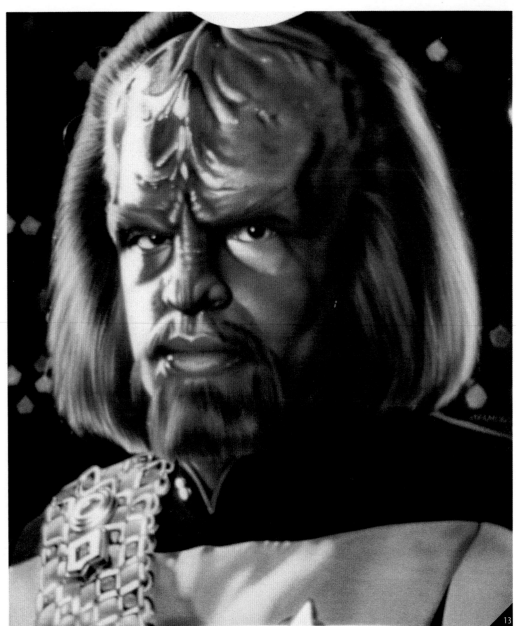

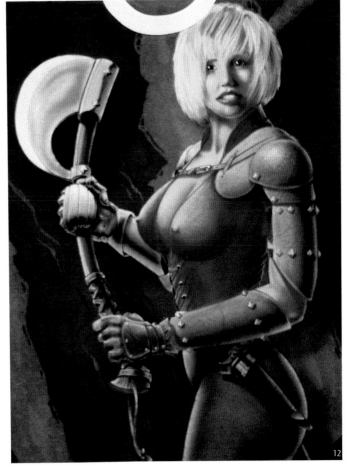

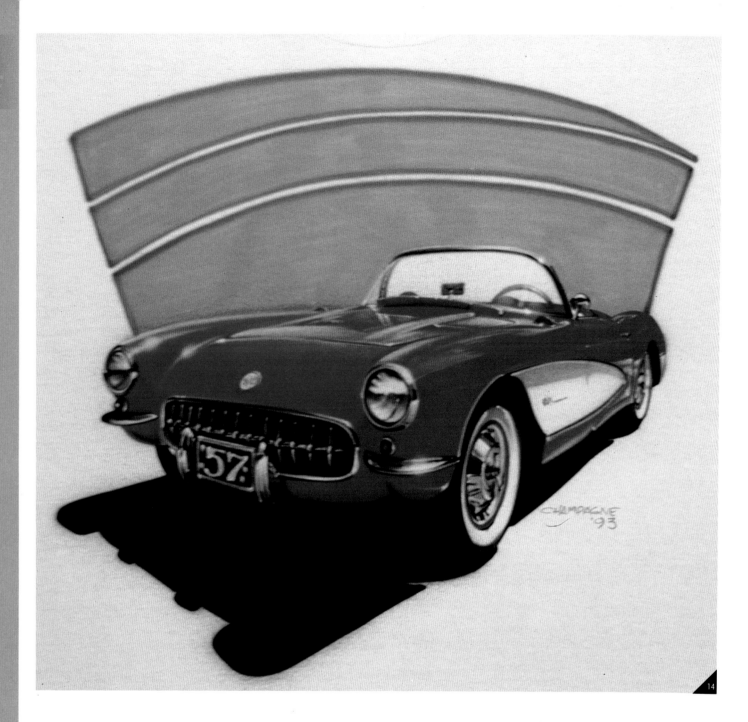

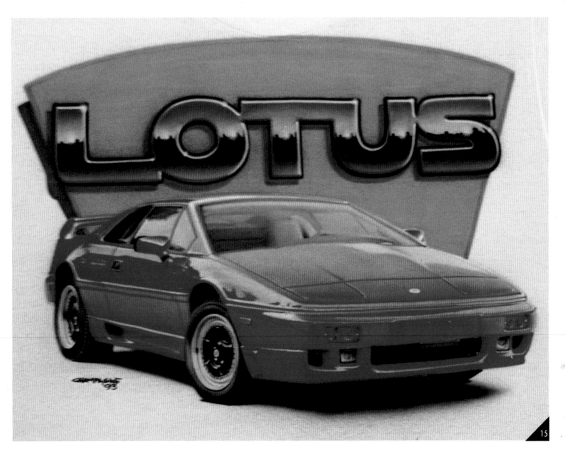

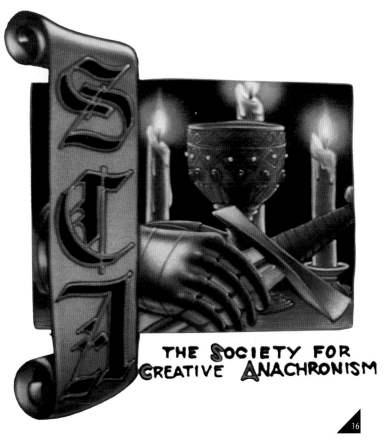

THE SOCIETY FOR CREATIVE ANACHRONISM

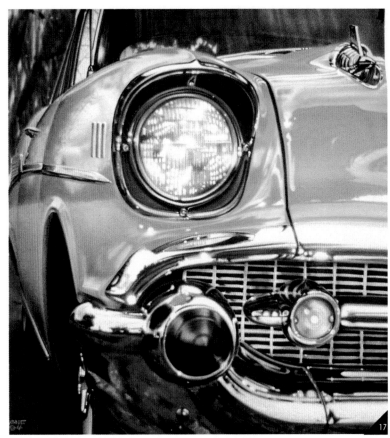

Facing Pages:

Ran No Sato

Dogashima

Orchid Series

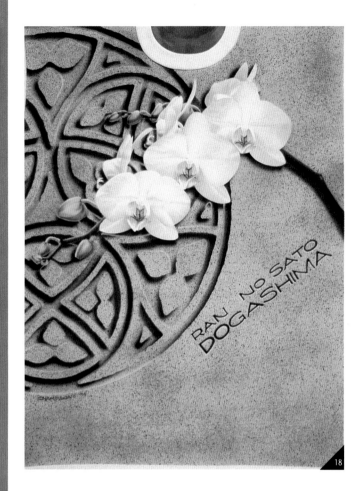

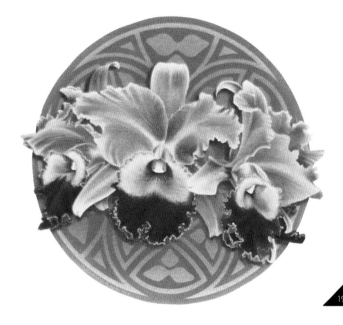

DON ASHWOOD

Hot Air Designs
170 Miracle Strip Parkway
Fort Walton Beach, FL 32548
904-243-8713

MICHAEL ASTRACHAN

Island Airbrush
470 Louis Avenue
Meriden, CT 06450
203-498-0455

RICH CHAMPAGNE

P.O. Box 207
Bourg, LA 20343

STEVE DRISCOLL

15051 Greenhaven
Suite 218
Burnsville, MN 55306
612-631-8786

SCOTT FITZGERALD

Unavailable

TERRY HILL

Hot Air Designs
170 Miracle Strip Parkway
Fort Walton Beach, FL 32548
904-243-8713

JÜREK

P.O. Box 1455
Provincetown, MA 02657
508-487-2590

TIM MITCHELL

Tim Mitchell Creations
7718 Kingman Street
Panama City, FL 32408
904-235-2315

KENT LIND

4328 Lexington Point Parkway
Eagan, MN 55123
612-631-8786